BY THE SEA

ROBERT FARBER

Senior Editor: Robin Simmen
Editor: Amy KL Borrell
Graphic Production: Ellen Greene
Design Consultant: Dominick Spodofora

First published 1987 in Los Angeles, California by Melrose Publishing Company

Library of Congress Cataloging-in-Publication Data
Farber, Robert, 1944-
By the Sea/Robert Farber.
 p. cm.
Photographs by Robert Farber and quotes by a variety of noteworthy personalities all focusing on the sea.
ISBN 0-8174-3648-0
 1. Marine photography. 2. Photography of water. 3. Sea in art.
 4. Farber, Robert, 1944- I. Title.
 TR670.F37 1996 96-23986
 779'.37' 092—dc20 CIP

Manufactured in Hong Kong

1 2 3 4 5 6 7 8 9/04 03 02 01 00 99 98 97 96

ACKNOWLEDGEMENTS

Many people generously contributed time, support, energy, ideas, and expertise to this project. In addition to those who graciously consented to share their thoughts about being by the sea, the following people deserve special recognition.

I also wish to give special thanks to my mother, Charlotte Farber, whose positive attitude has brought me to this point in my life.

Jane Alexander
Anne Bancroft
Rona Barrett
Stephen Bishop
Bill Blass
Helen Gurley Brown
James Brown
Jimmy Buffett
Sammy Cahn
Basil Charles
Dick Clark
Judy Collins
Christopher Cross
Phyllis Diller
Jeff Dunas
Orest Dmytriw
Blake Edwards
Leatrice Eiseman
Erté
Blake Farber
Devon Farber
Judith Farber
Lee Farber

Eileen Ford
Whoopi Goldberg
Lou Gossett, Jr.
André Gregory
Judd Hirsch
Horst P. Horst
Richard Horst
Al Jarreau
Jessie
Betsey Johnson
Jean and Casey Kasem
Chaka Kahn
Ed Koch
Carol Judy Leslie
Ken Levinson
Sarah Lifton
Norman Mailer
Melissa Manchester
V. James Marfuggi
Virginia McHughan
Meatloaf
Peter Rodgers Melnick
David Metz

Richard Moll
Rosemarie Monaco
Ricardo Montalbán
Donna Murray
Leroy Neiman
Michael Newler
Yoko Ono
Ron Parker
Kenneth Polinski
Pat Rains
Edward Scharf
Robert H. Schuller
Thomas Smallwood
Captain Terje Sorensen
Mona Thalheimer
Jay Thomas
Liv Ullmann
Joan Van Ark
Larry Vigon
Peter Yarrow
Lady Jemima York
Henny Youngman

INTRODUCTION

"I must go down to the sea again..."
- John Masefield, "Sea Fever," 1902

The sea has always been a source of wonder, beauty, inspiration, and solace for me. I love the exquisite desolation of empty beaches in the early morning or late afternoon. I'm drawn to the mystery of the ocean—the strange, underwater world that few of us know. I'm fascinated by the power of the sea, which I perceive as a gentle, creative force. And because I've always been taken with the paintings of the Impressionists, the Mediterranean in particular is for me a tangible link with their world.

I'm not really sure why I respond to the sea with such intensity. Perhaps it's the ocean's role as the wellspring of life, or maybe it's simply the notion of escape and adventure it represents. Perhaps it's the unique paradox of its predictability and unpredictability, or even the sense of freshness and renewal it brings. Whatever the reason, this much I am sure of: Regardless of its geographic location, the ocean is one of the most extraordinary settings on earth.

Looking back, I realize that the sea and the world that borders it are embedded in my earliest memories. As a child I spent my summer vacations with my family at the New Jersey shore, and the impressions I gathered there have shaped my attitude toward the ocean ever since.

The sea of my childhood—like that of today—was primarily a series of sensory experiences. There was, of course, the look of the white, mounded sand; the smell of the salt air; and the changing hues and demeanor of the water itself. These are fairly universal perceptions.

But there was also the feeling of the sand underfoot and, later on, in my bed. There was the humidity in the air, the tightness of my skin after a day on the strand, the sounds of the waves crashing onto the shore, the call of the seagulls, and the shouts of the children playing.

There were other, tangential, memories as well: the old wrinkled man who had been sitting in the sun all day, probably for most of his life, his skin like tanned

leather; the crackling of hotdogs roasting; the white on white look of the old clapboard pavilions. And I remember especially vividly the wonderful early morning visits to the dockside fish markets with my parents.

All of these experiences established the seaside as a special place early in my life. But beyond the fond recollections of my childhood are other, more fundamental ties with the sea. Foremost among these is probably the sense of continuity the ocean offers—continuity between continents, between people, between past and present.

But just as the sea weaves places, people, and times together, so it separates them, and I find these distinctions irresistible as well. When you cross the Italian/French border along the Mediterranean, for example, the coastline doesn't change, but your sense of place instantly is altered. The change is manifested in the architecture, the people, and their accouterments. It's apparent in the way the cabanas are set up, in the palette, in a graphic quality that is more pronounced in Italy. You see it in the way people look and dress, how they eat their lunch, and what accessories they bring to the beach.

This astonishing diversity converts the beaches of a region into microcosms of life and culture. Whether it is in California, New England, Florida, the north of France, the Italian Riviera, or anyplace in the world, that vitality makes the beach, for me, a perennially fresh and stimulating photographic subject.

Because the sea and the world around it has long been one of my favorite artistic themes, *By the Sea*, like the ocean itself, wasn't so much conceived as it evolved. The photographs that are reproduced on the following pages were taken over four years and represent extensive travel and countless rolls of film. Although I believe that all the images ultimately speak for themselves, for purposes of clarity, I've recorded my own thoughts and technical data in the background notes that accompany the images in the back of the book.

I recognize, however, that each viewer is bound to have associations with the seaside that differ substantially from mine. In an effort to account for those impressions and to imbue the photographs with added emotional dimension, I asked a number of people to share with me their feelings about being by the sea without ever seeing the images included here. These people represented many regions, occupations, and segments of society, but all graciously agreed to reveal their thoughts. The response was overwhelming, and I'm sorry I couldn't include them all in the book. I found their comments to be extensions both of their personalities and of their deep, inner feelings. I hope you are touched, as I was, by their wit, candor, and eloquence.

For me, it is that rich perspective and depth of feeling, visual and verbal, that lie at the heart of *By the Sea*. I hope you will enjoy the book as much as I enjoyed producing it.

Robert Farber

In memory of
Charlotte & Norman Farber

A portion of the author's royalties are being donated to
The American Cancer Society.

The images on the following pages reflect my personal feelings about being by the sea. I'm sure that different people will respond differently to each photograph, recalling memories, perhaps, or simply turning the page. Because of the unique, individual nature of the images, I have attempted to account for different perspectives by asking people from all walks of life, from all parts of the country, and even from different parts of the world, to share the moods or feelings that being by the sea evokes in them. Their comments are their own, for the most part in their own handwriting; the words have not been changed or edited and reflect the experiences and personalities of the people who contributed them.

... the tide would come up over the sand as swiftly as a shadow descends on the hills when the sun lowers behind the ridge, and before long the first swells would pound on the bulkhead below my bedroom window, Boom! the waves would go against the wall, and I could have been alone on a freighter on a dark sea.

Norman Mailer

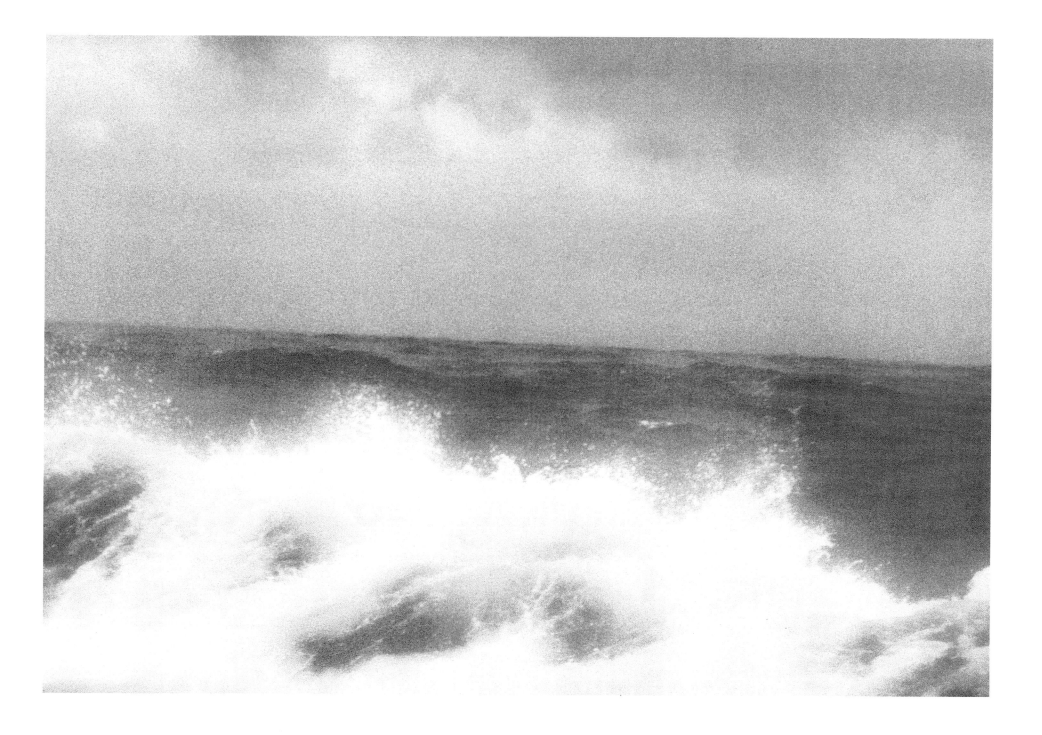

The sea represents the continuity of life ... its ebb & flow ... we have lived before as surely as we live today & we will live forever.

Ron Parker

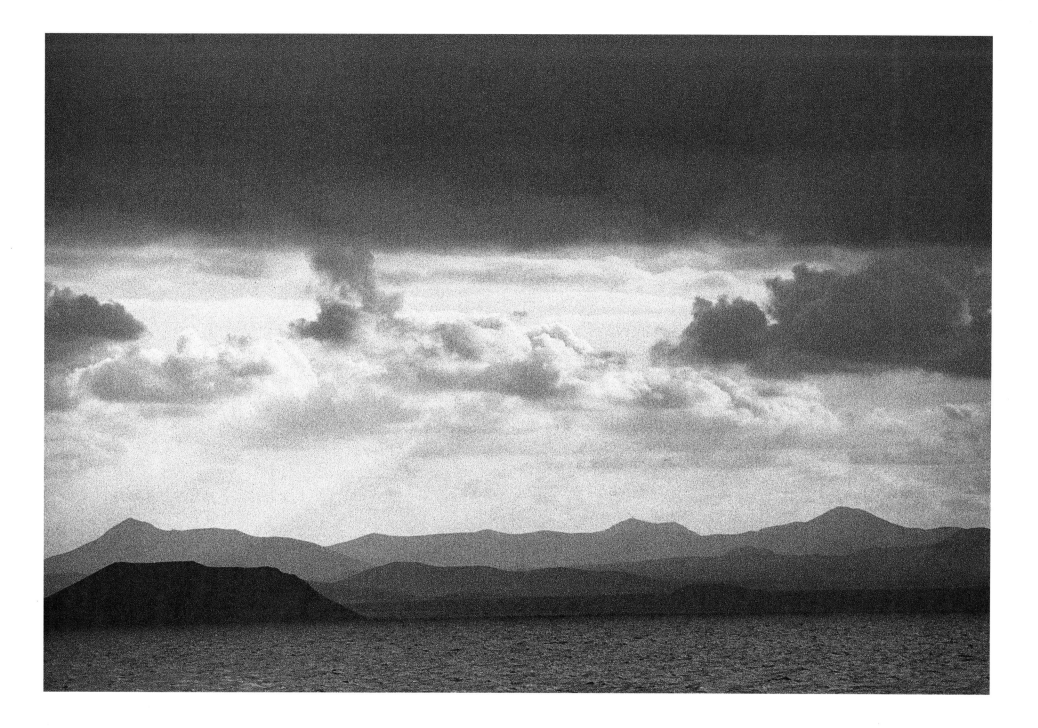

*When I look to the sea
I see Peaceful and Powerful
Infinity*

Lou Gossett

No. 3
LOU GOSSETT, JR., ACTOR

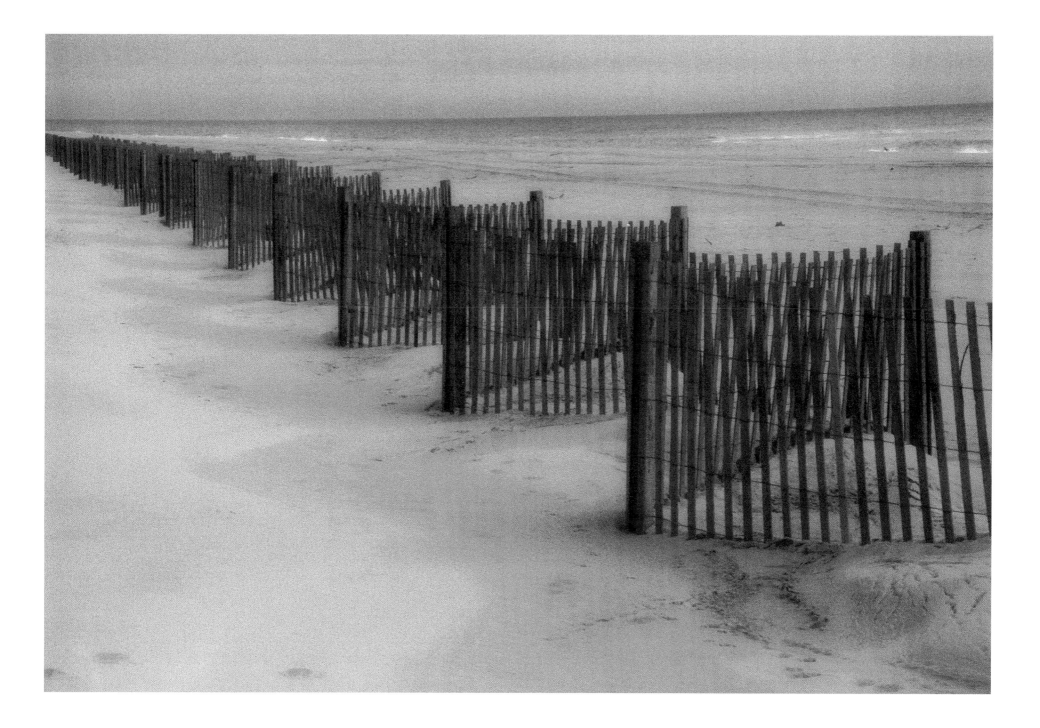

I love the sound and the look of the surf.

Ed Koch

No. 4
Ed Koch, former mayor, New York City

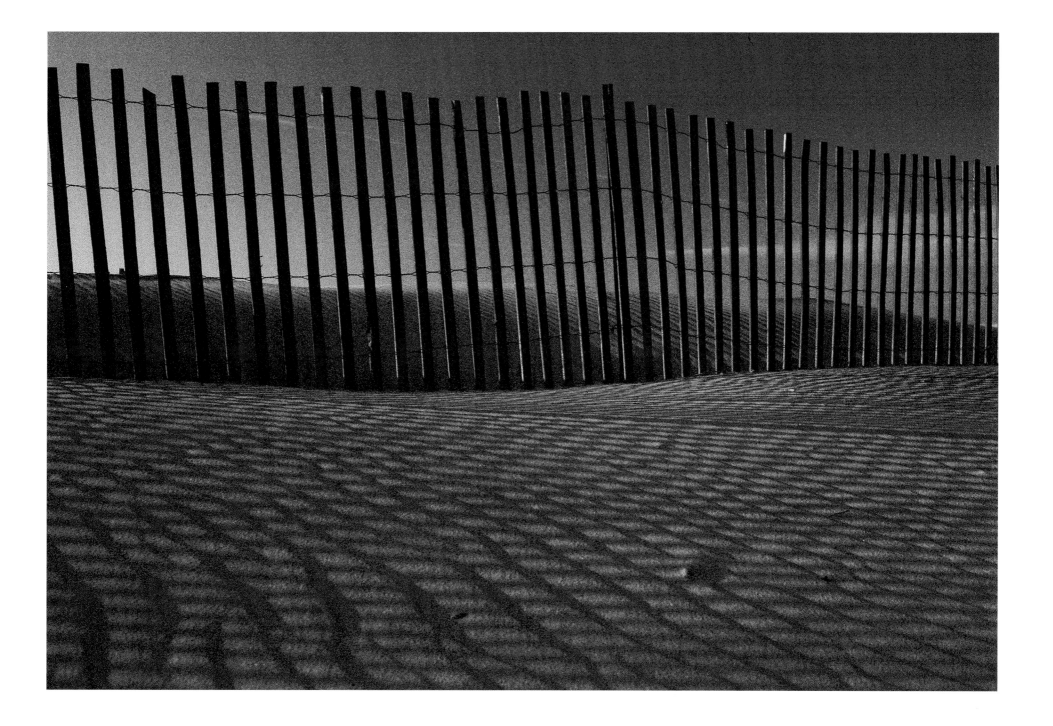

The Sea evokes in me infinite thoughts and moods; serenity, turmoil, the beginning of Life, the unconquerable End. — Majestic, awesome, often cruel but always.... indescribably beautiful. —

Ricardo Montalbán

No. 5
RICARDO MONTALBÁN, ACTOR

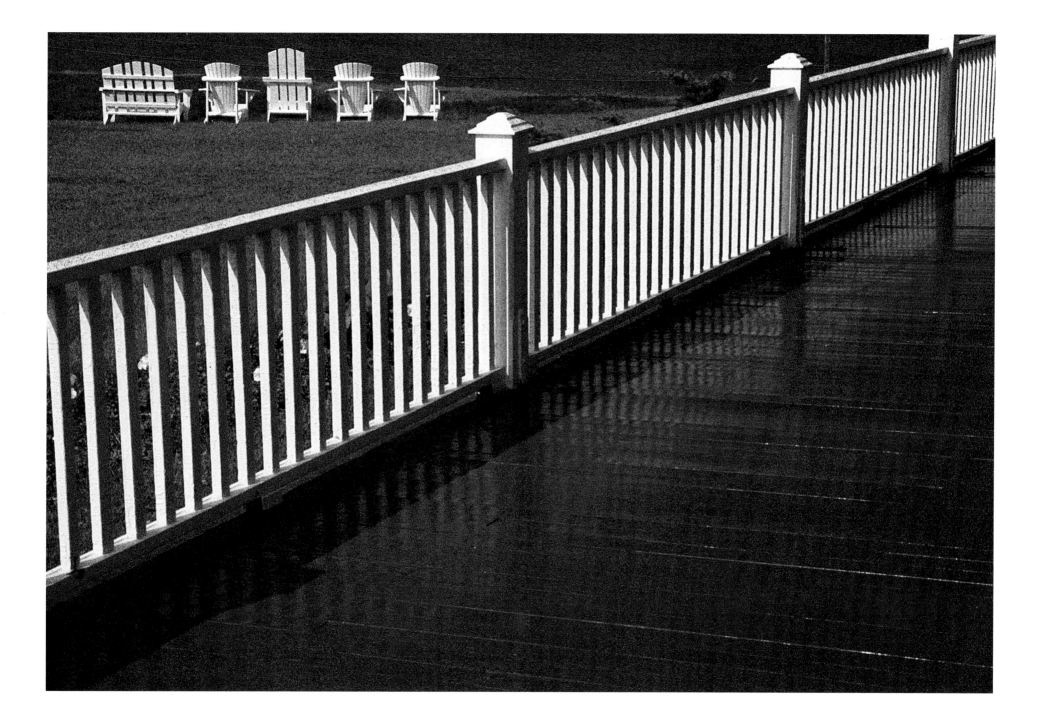

The sea? Let's see.
I don't know what to say.
Perhaps you'll understand me
If I put it in this way:
I'll stay on _terra firma_,
To leave it makes me squirm-a;
You won't catch _me_ a-swimmin' in the bay!
 —Richard Moll

I love to relax seaside looking out over the blue waters of the mediterranean visualizing in my minds eye the ingredients of the days catch for my Bouillabaisse

LeRoy Neiman

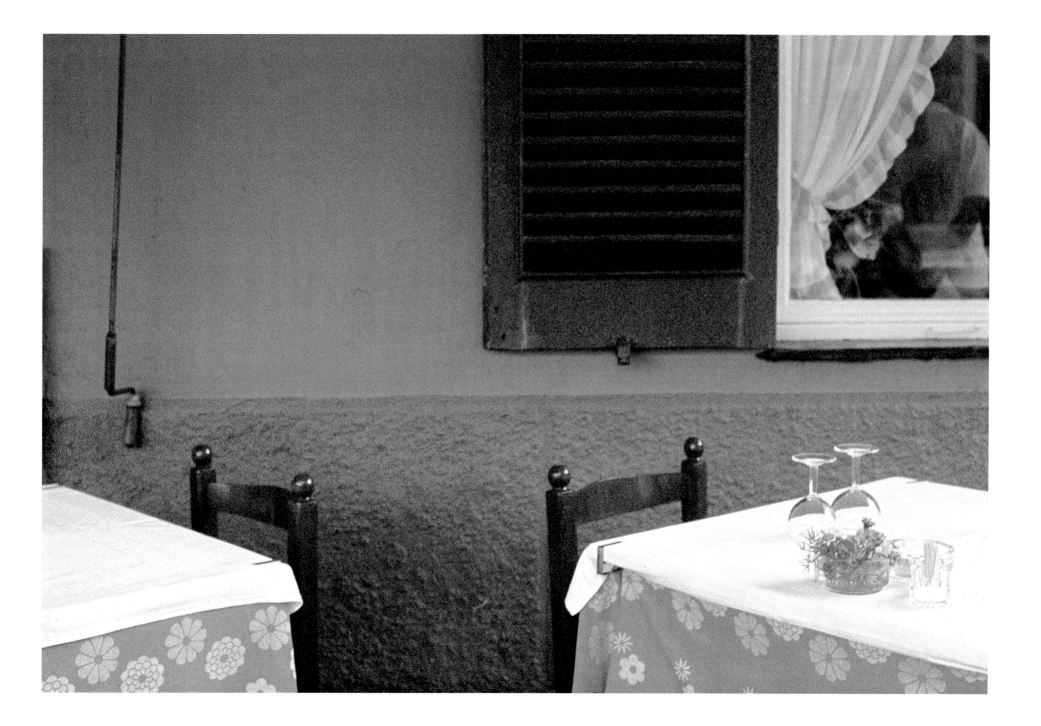

I Love The Sea
I Love The Beach
I Hate The Sand.........
In My Lunch

Two Out of Three Ain't Bad

No. 8
MEATLOAF, RECORDING ARTIST

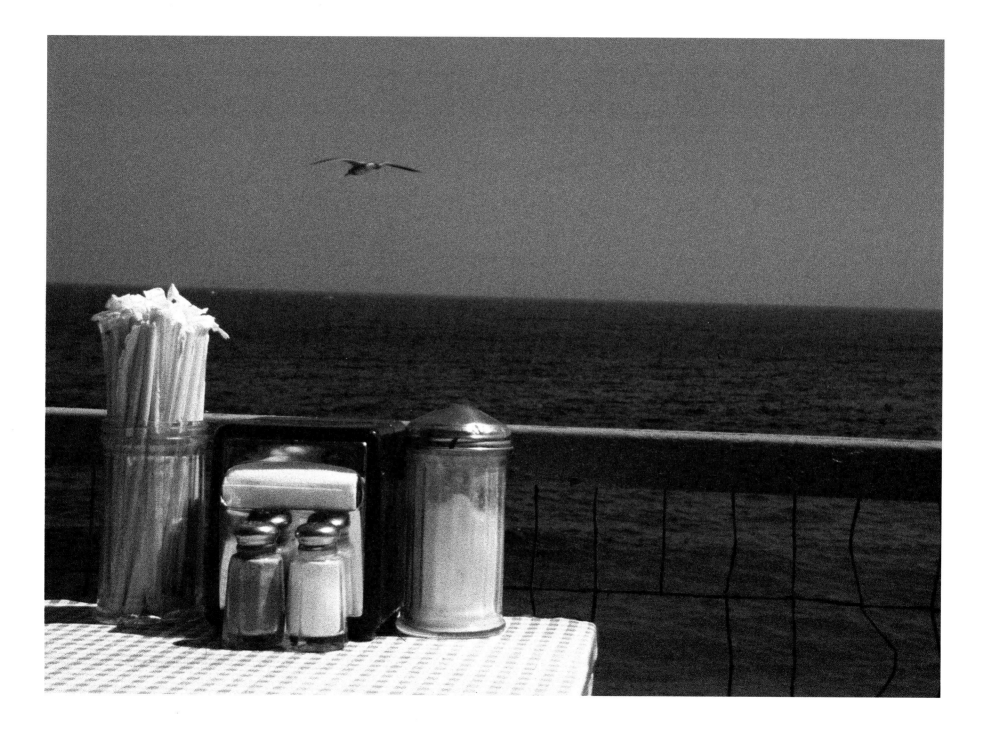

....... a rare and special gift!

Al Jarreau

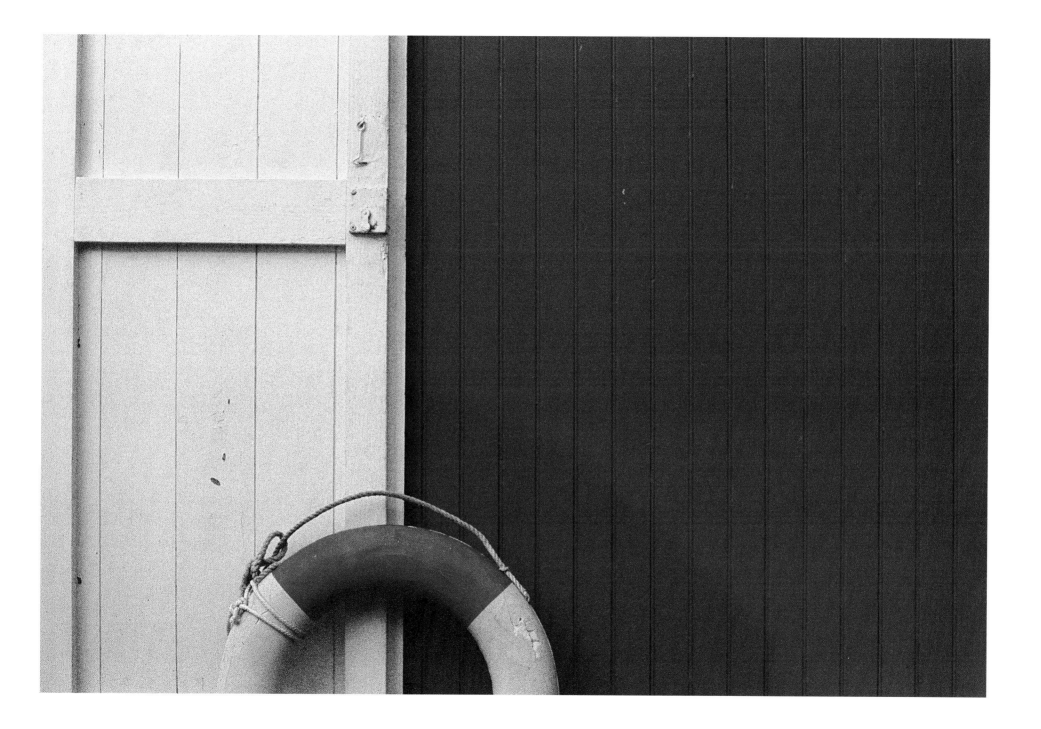

The incessant thump of the surf
Heart beat of the world
Blood of the earth.
I sleep well.

Jane Alexander

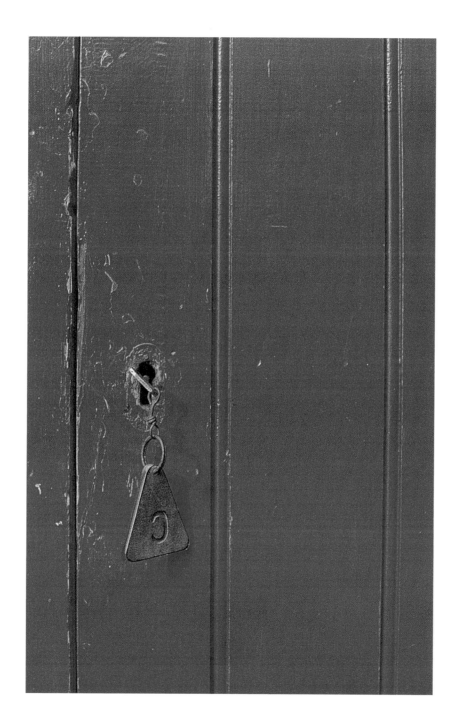

the last time I was at the seashore,
I saw Karl Malden and I knew my
room had been robbed..........

Jay Thomas

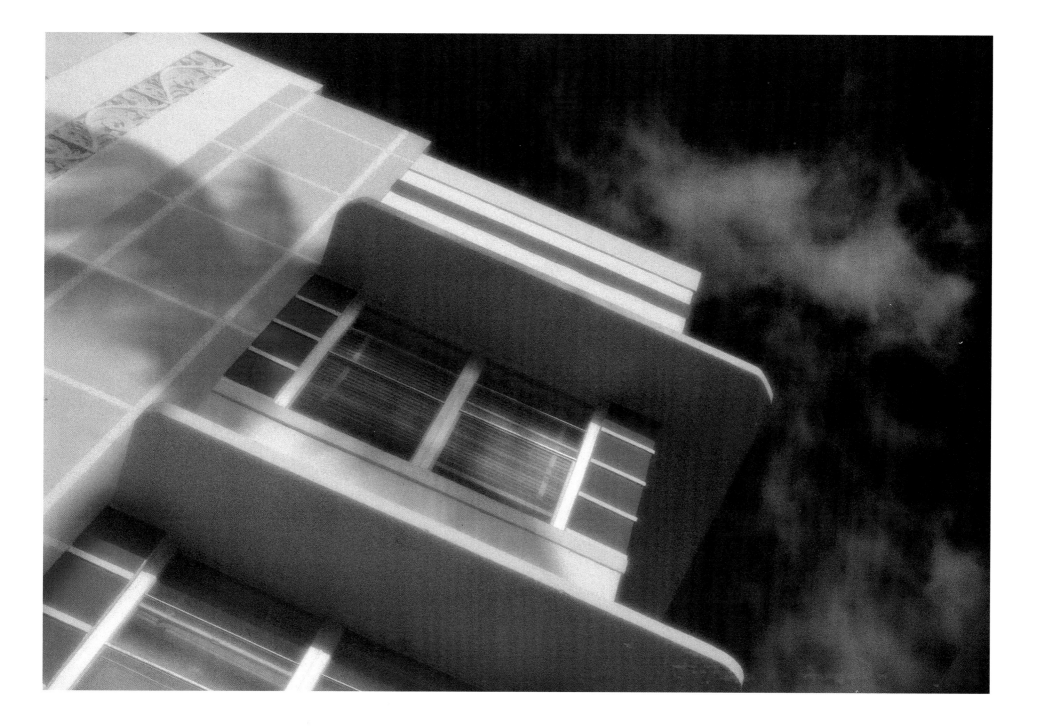

I have a recurring dream about the sea: I'm standing near the water's edge, watching the waves breaking, and all of a sudden a huge swell comes roaring in, enveloping everything in darkness. There's never any real fear in my dream, just a fleeting moment of apprehension, and then this mysterious realization that I am living and breathing under the water's surface, beneath all that roiling power, and the knowledge that nothing is going to hurt me.

Peter Rodgers Melnick

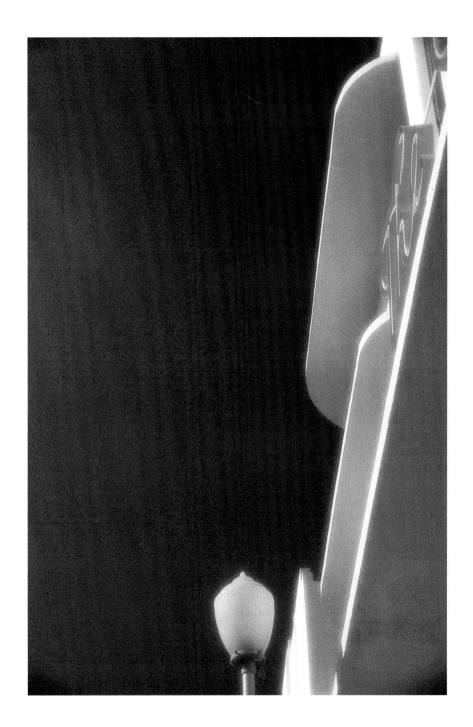

Twenty years of Surfing its my backyard full of memories

Kenneth P. Polinski

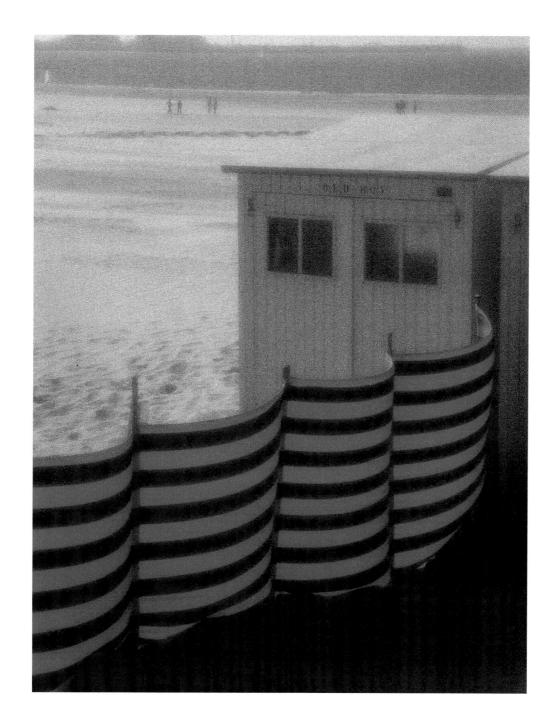

What extraordinary images —
an instant vacation to a place of calm —
Wonderful!

Peter Yarrow
PP+M

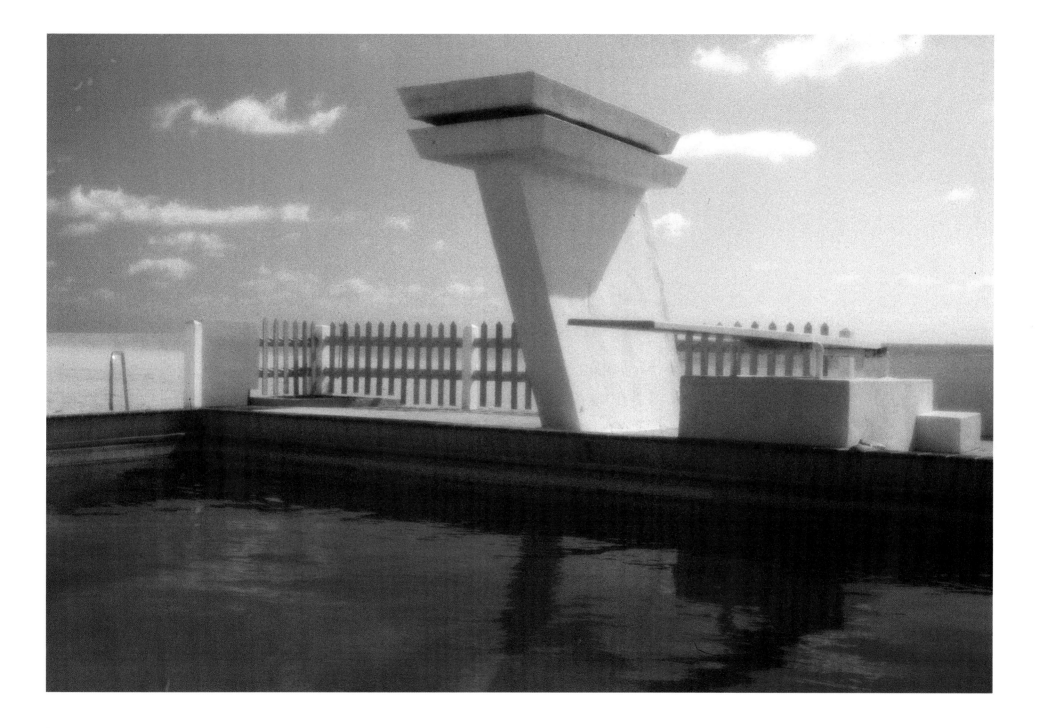

I always need the sea

Bill Blass

No. 15
BILL BLASS, FASHION DESIGNER

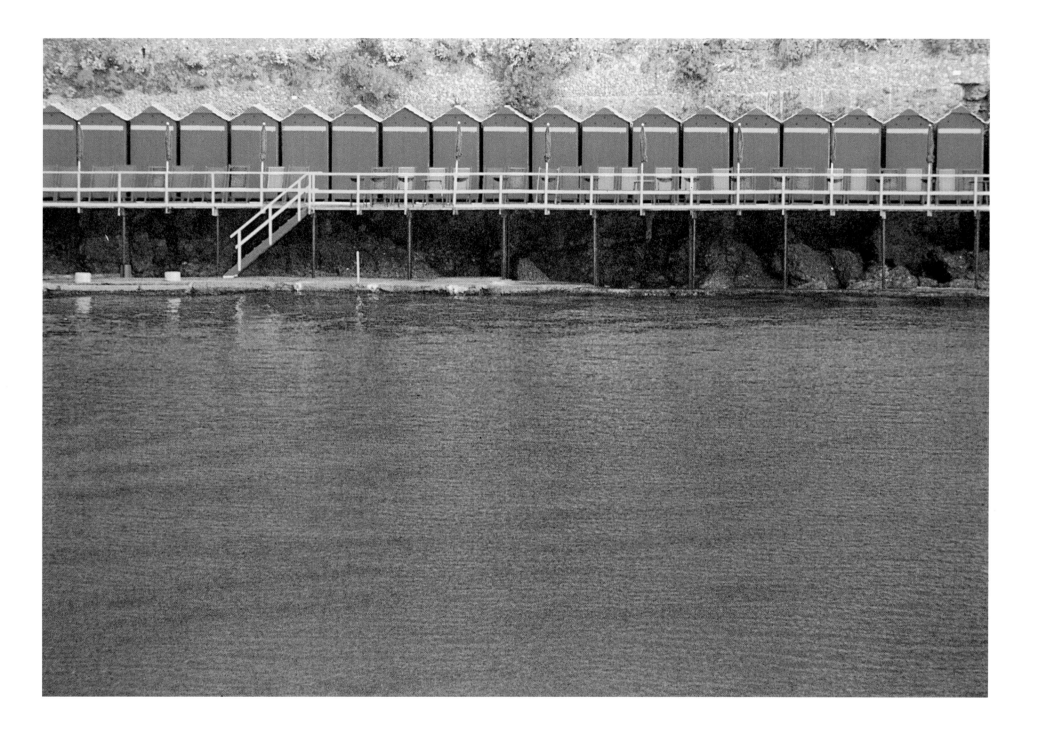

My "theory" is that many of us share a more direct "primal" relationship with the sea. It's the feeling of "Going Home", a complex amalgam of peace and serenity, knowledge and innocence. I smile and breathe easier.

ALEXANDER JULIAN, FASHION DESIGNER

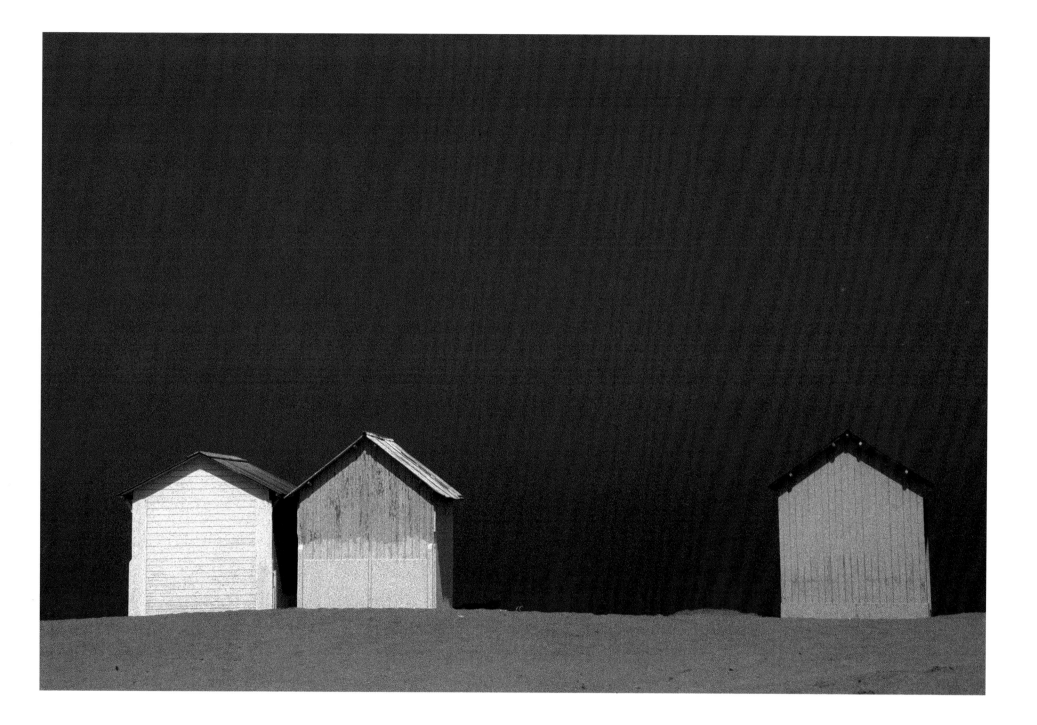

Living by the sea reminds
me of what's really important —

Dick Clark

No. 17
DICK CLARK, TV PERSONALITY/PRODUCER

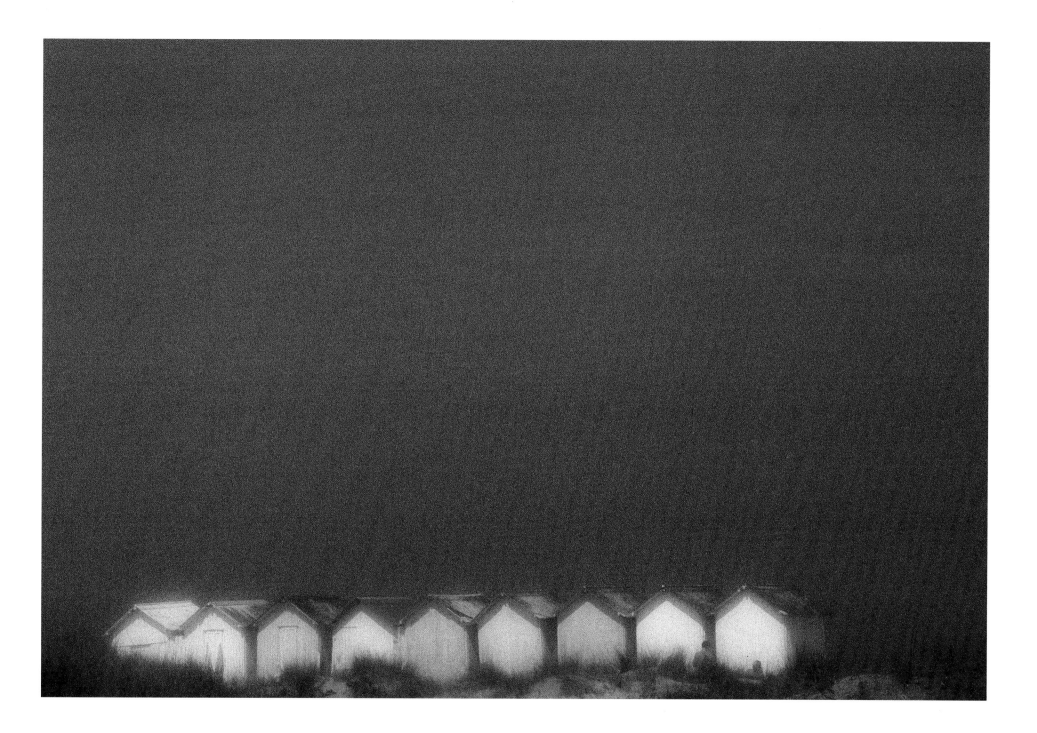

THE SEA HAS BEEN HERE FOR EONS BEFORE ME AND WILL BE HERE LONG AFTER I AM GONE. I THINK OF MY CHILDREN AND MY CHILDREN'S CHILDREN AND I AM COMFORTED BY THE RHYTHMIC CADENCE OF THE CONTINUING WAVES.

Leatrice Eiseman

No. 18
LEATRICE EISEMAN, AUTHOR, ALIVE WITH COLOR; DIRECTOR, PANTONE INSTITUTE

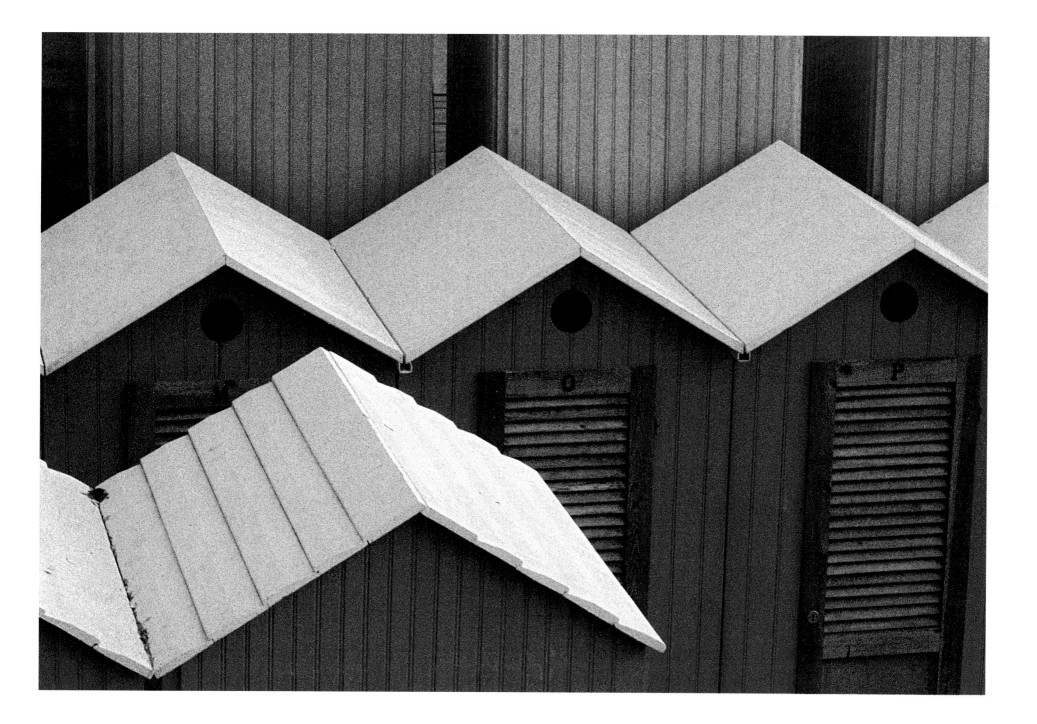

"Music of the ocean surf is suiting to the body and sole"

"Ocean surf can ascend the mind to the picturesque skys above"

Alexander R. Mottola

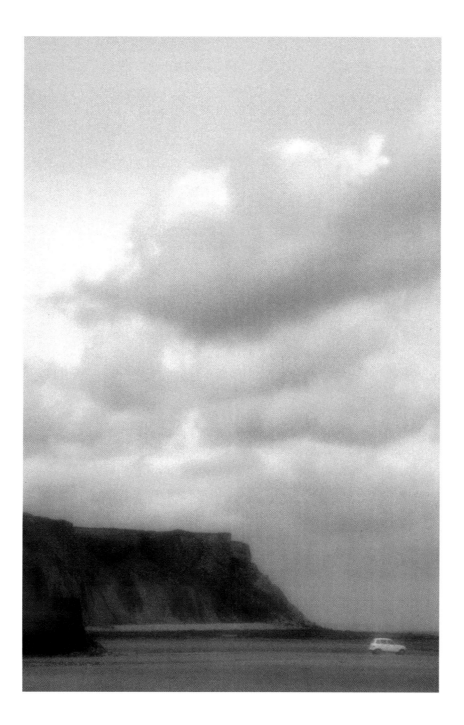

When I'm sitting by an old white weathered shack overlooking the waves with the smell of the salty sea air, my body tingling from the day's sun, and my mouth filled with the best lobster and steamers and beer —
I'm in heaven!

Judith Farber

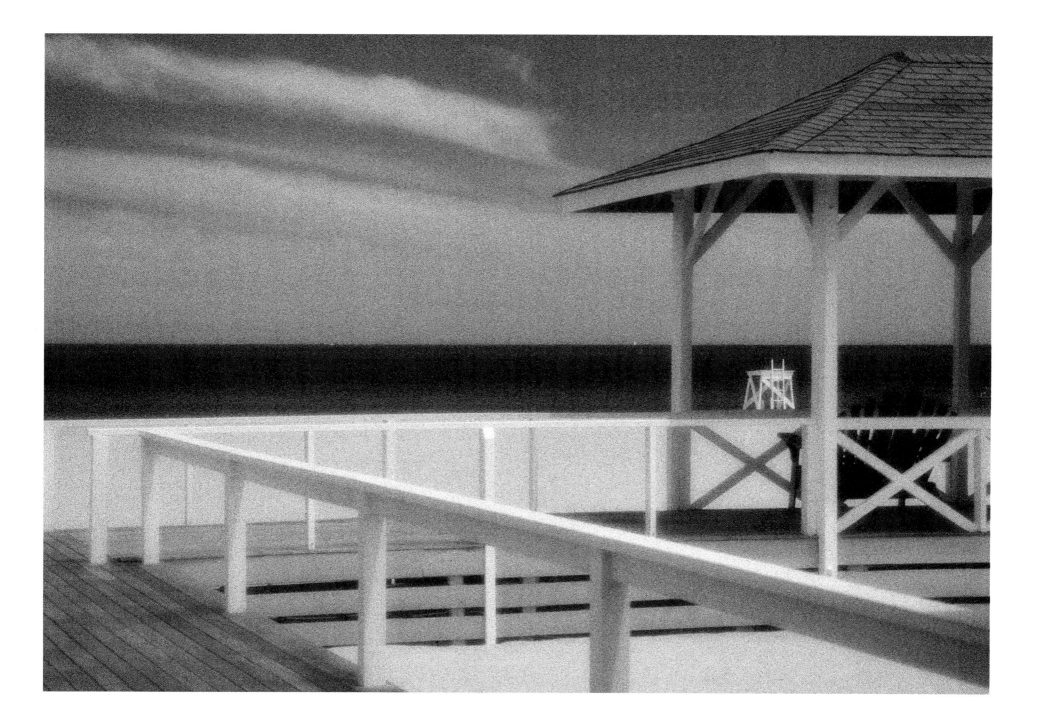

the Sea!
"My truly Compadable sleeping
Companion"

[signature] De La Fonda.
Mexico!

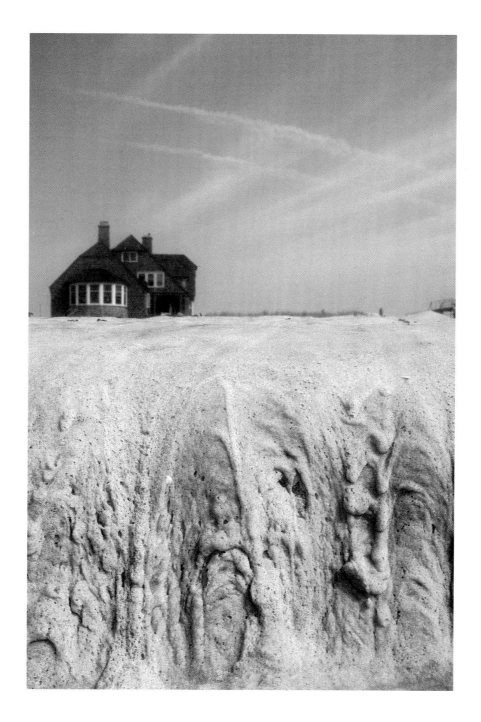

It's not far down to Paradise at least
it's not for me! Just down "By the Sea"

Christopher Cross

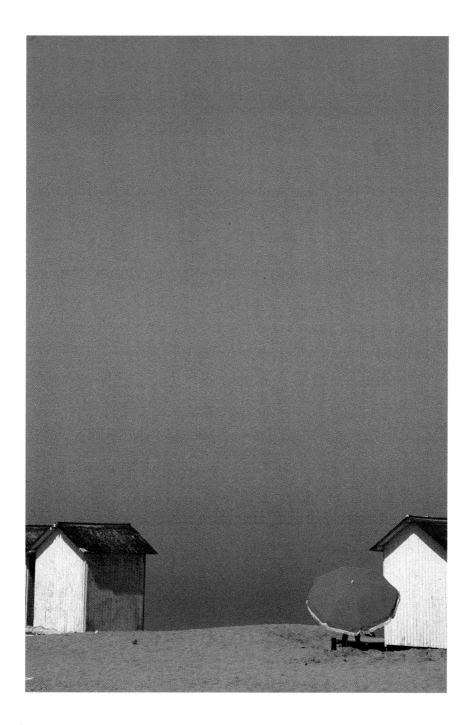

Shortly after my father died, my husband took me to Laguna for a weekend of quiet and reflection. As we watched the sun slowly set, and the accompanying waves hit the shore, I was struck deeply with a profound and comforting thought: — no matter how far out from shore — no matter how large or small the wave — they would ALL hit the shore sooner or later.

And they did...And suddenly I didn't miss my father so much anymore.

No. 23
JOAN VAN ARK, ACTRESS

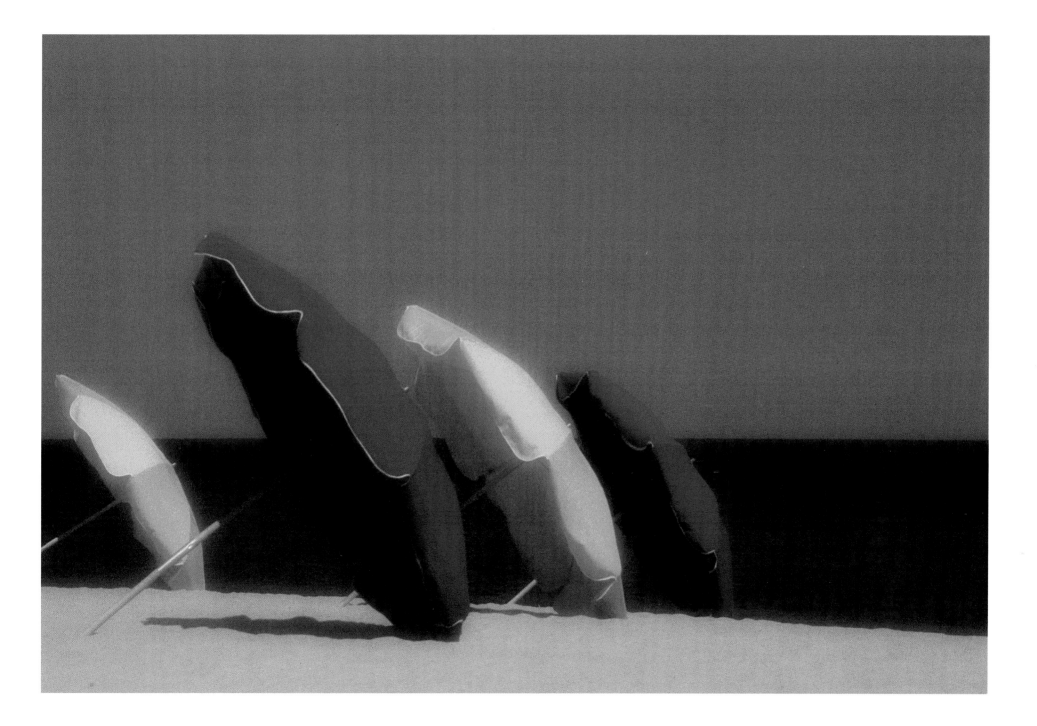

By the sea I am free, floating, peaceful. All anxiety

is gone...and my thoughts wander to how lovely it would

be if each and every soul in the world could share these

feelings. Indeed, ever-lasting peace and love would be

ours forevermore. I dream alot by the sea.

Rona Barrett

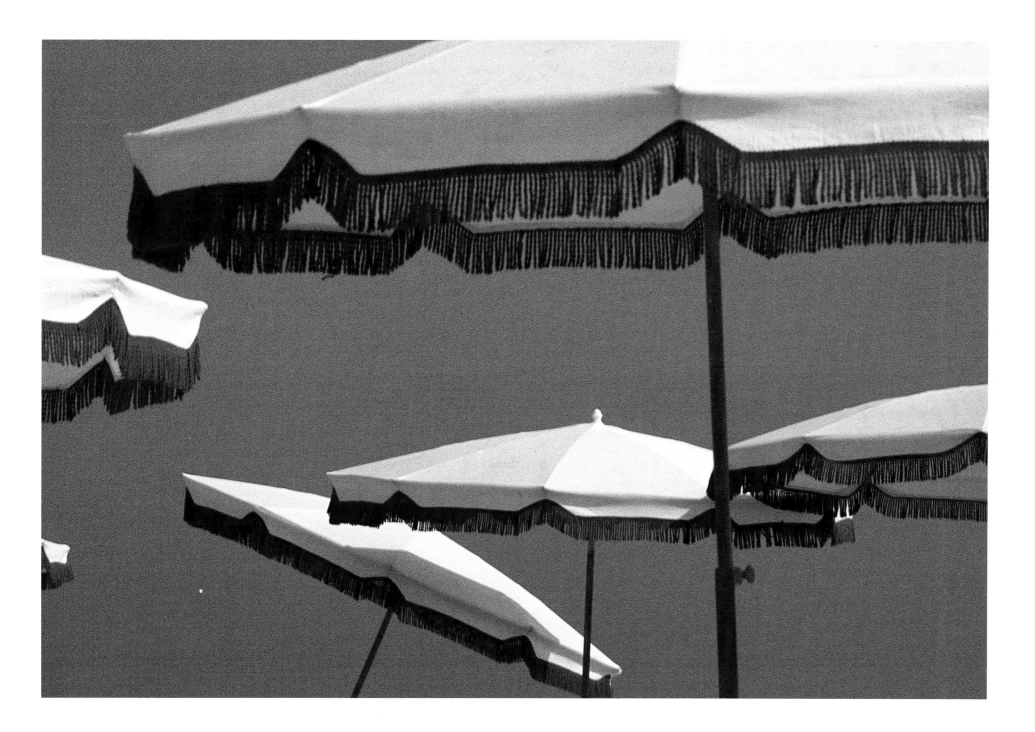

The sea refreshes me through each of my senses.

Charles Silverberg

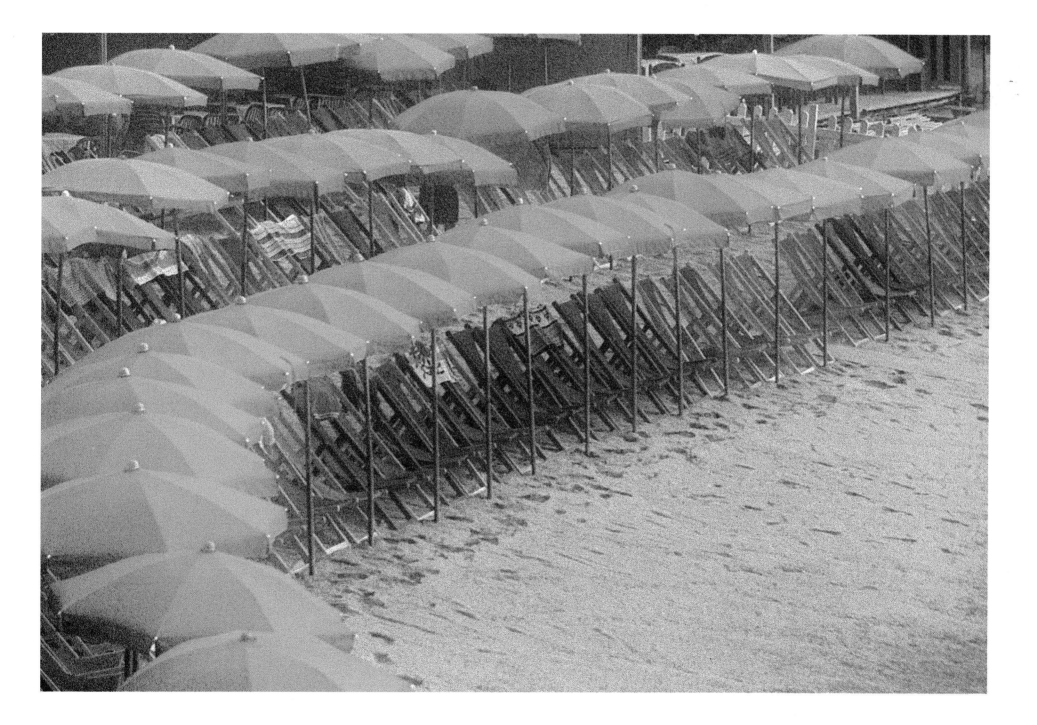

Incredible sunsets and a relaxing effect not easily forgotten.

Edward Scharf

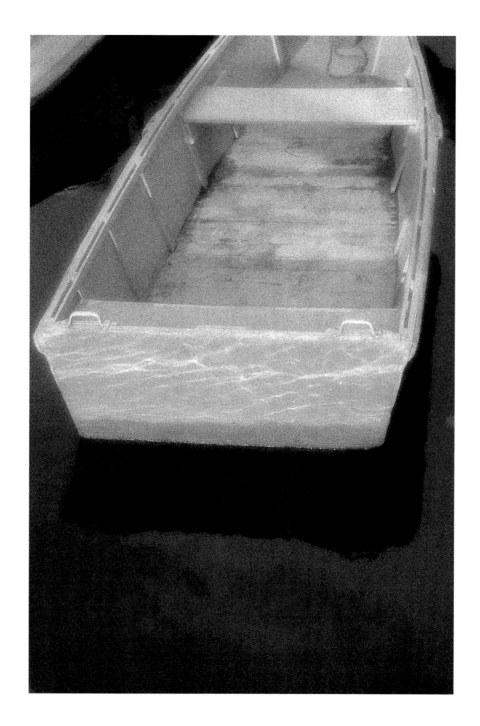

To Me the Sea's a Neonic Balming
conductor;
" and one of The Few "Great equalizers"
To all Mankind.

Chaka Khan

No. 27
CHAKA KHAN, RECORDING ARTIST

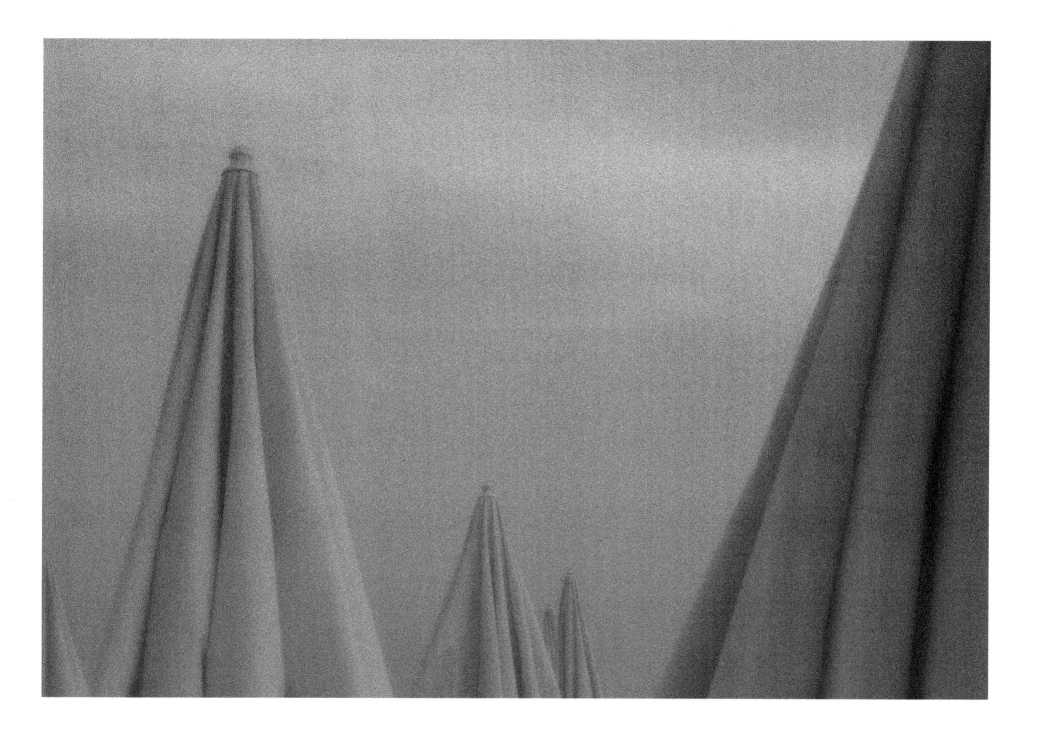

When I was young I knew a troubled girl.
She sang and danced in the waves.

Melissa Manchester (signature)

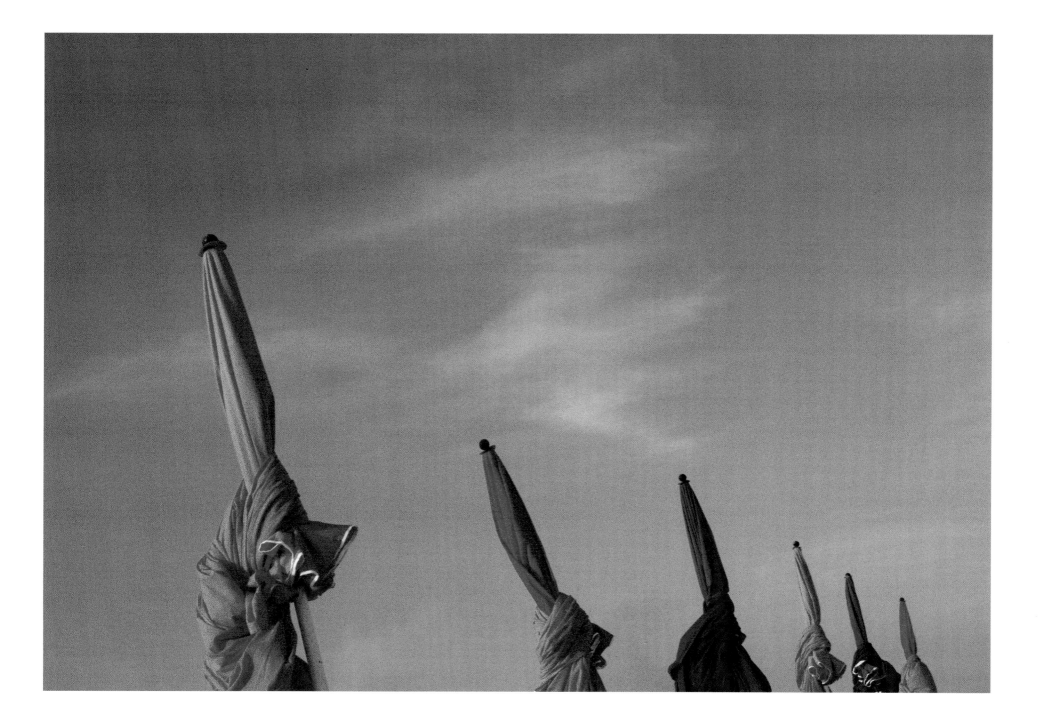

"L'âme de l'homme
Est semblable à l'eau;
C'est du ciel qu'elle vient.
C'est au ciel qu'elle monte.
Et il lui faut redescendre sur terre
En un changement éternel."

French was my first language. As a little boy, I
made sand castles on the beaches of Normandy.
Long, Long Ago. André Gregory

No. 29
ANDRÉ GREGORY, FILM DIRECTOR

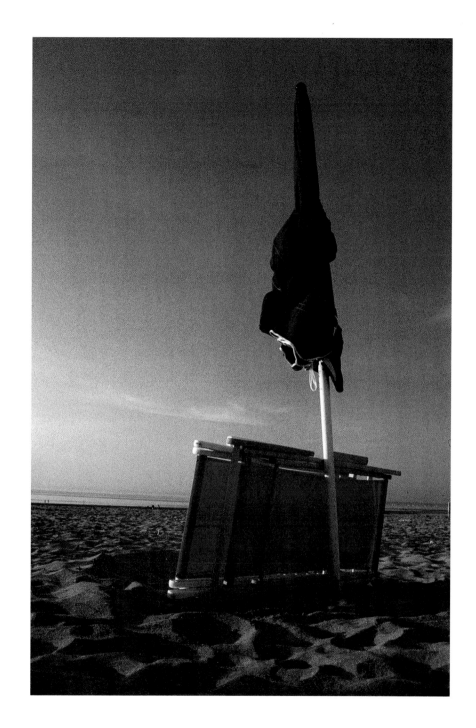

The sea has always been
a wonderful inspiration for
me.
I can't live without seeing
the sea a long time.
Every year I am spending two
months in Barbados and two
months in Mallorca, and my
best ideas are born in these two
places.

No. 30
ERTÉ, ARTIST

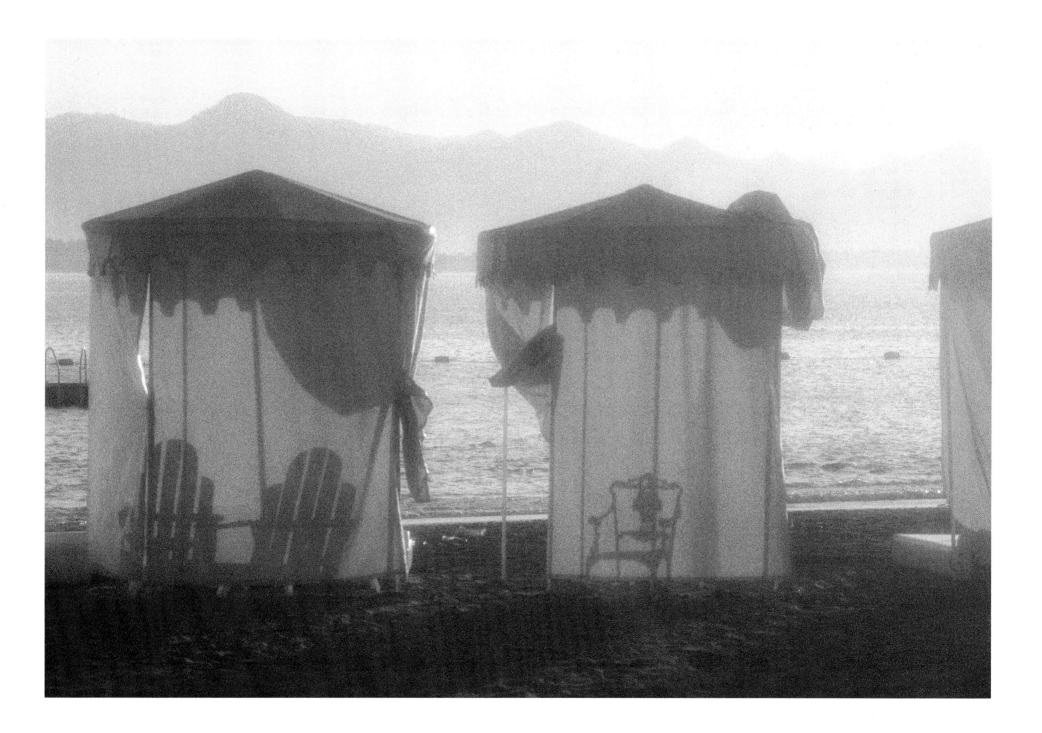

The sea is the eternal heart beat
of the earth and its' rhythm makes us
feel immortal.

Jean and Casey Kasem

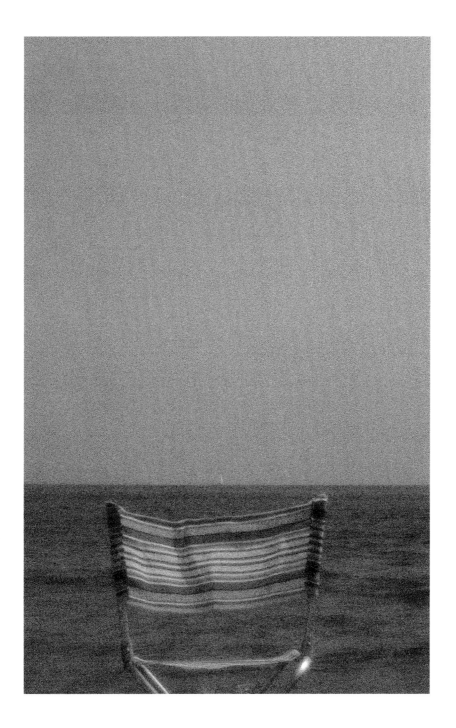

When I am at the oceans side I am
usually more aware of the continuity
of life here and hereafter; the order of
universal law is present — and I
am conscious of the ever-changing
nature of life. I feel united
and at peace with the planet and
the universe. Judy Collins

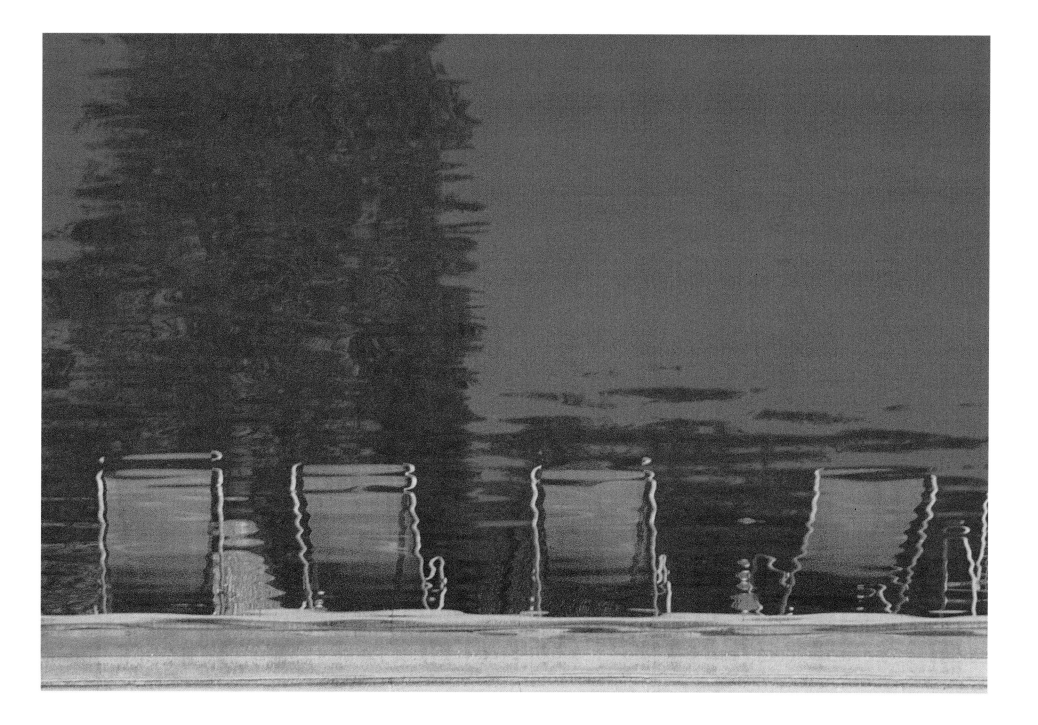

The sea stands for peace, love, and tranquility.
The things that we struggle for every day.
It is a miracle,
It is powerful,
It is life.

Lee Farber

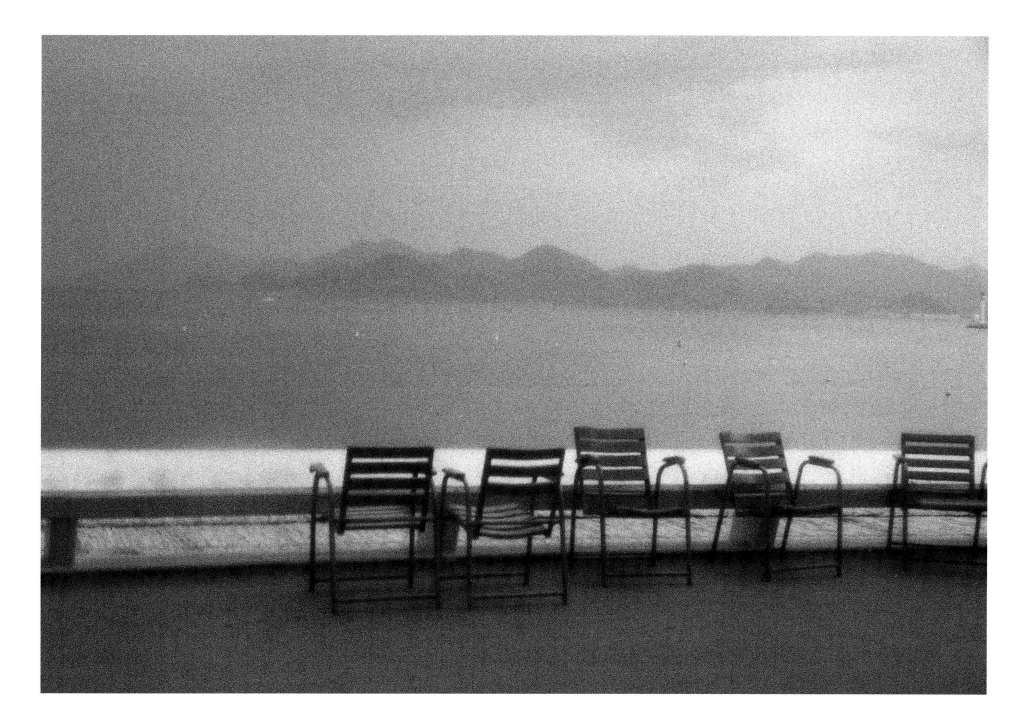

I get sea sick, when I look at wet wash. Take the sea please.

Henny Youngman

No. 34
HENNY YOUNGMAN, COMEDIAN

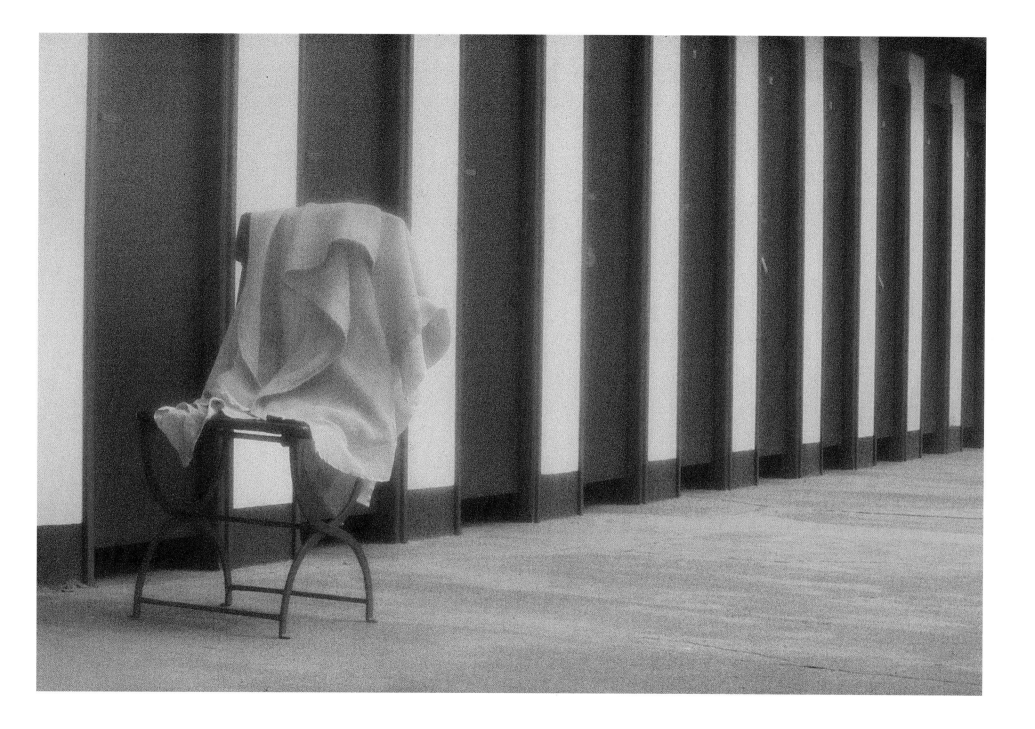

" My world is the best of all... the endless sky, the leeward sea, and behind a beautiful tropical hill. Life is good "

Basil Charles
Mustique

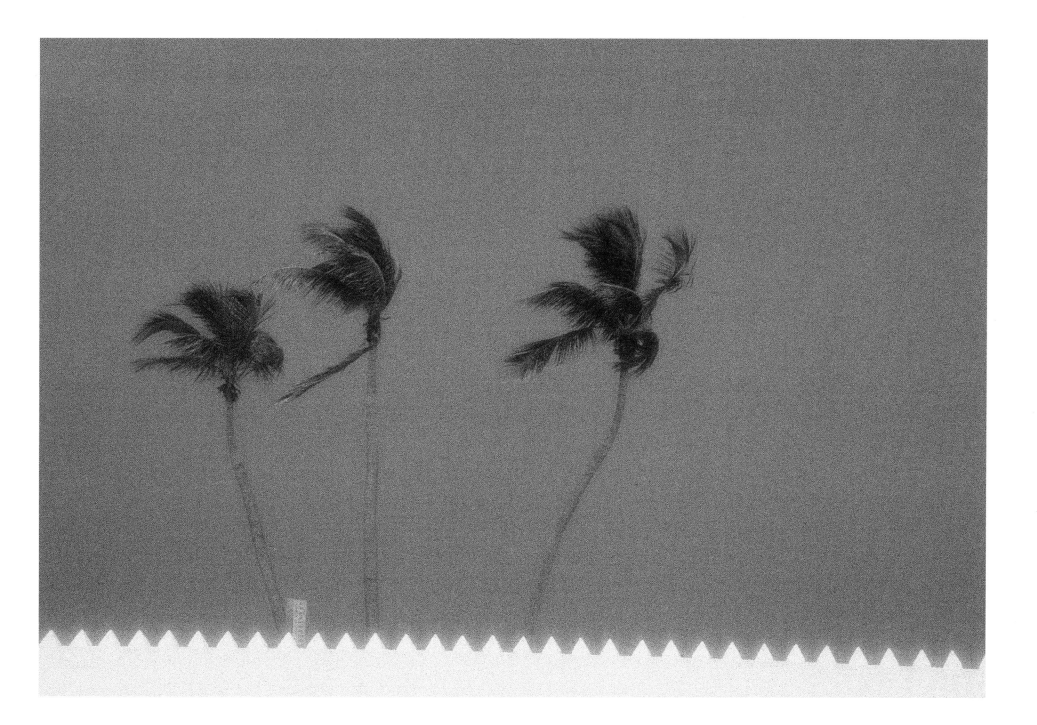

Creativity is possible
when the subconscious
mind is at peace.
The sea sets the
scene for settling
the subconscious with
a spirit of serenity

R H S

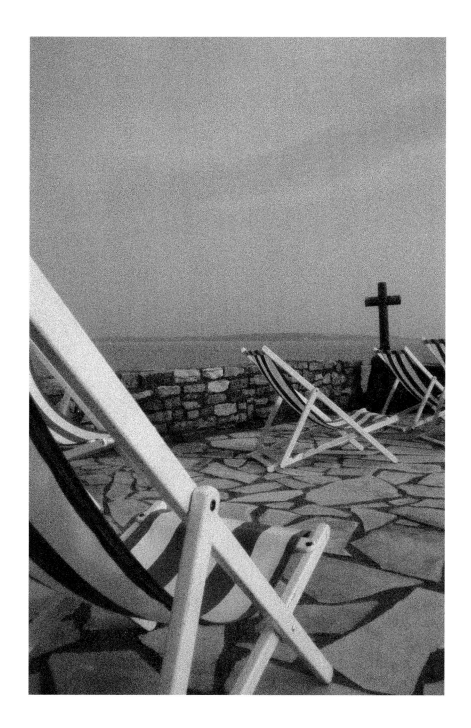

IF I LIVED IN THE SEA...

I WOULD WISH TO DESIGN FOR THE MERMAIDS.

BETSEY JOHNSON.......

No. 37
BETSEY JOHNSON, FASHION DESIGNER

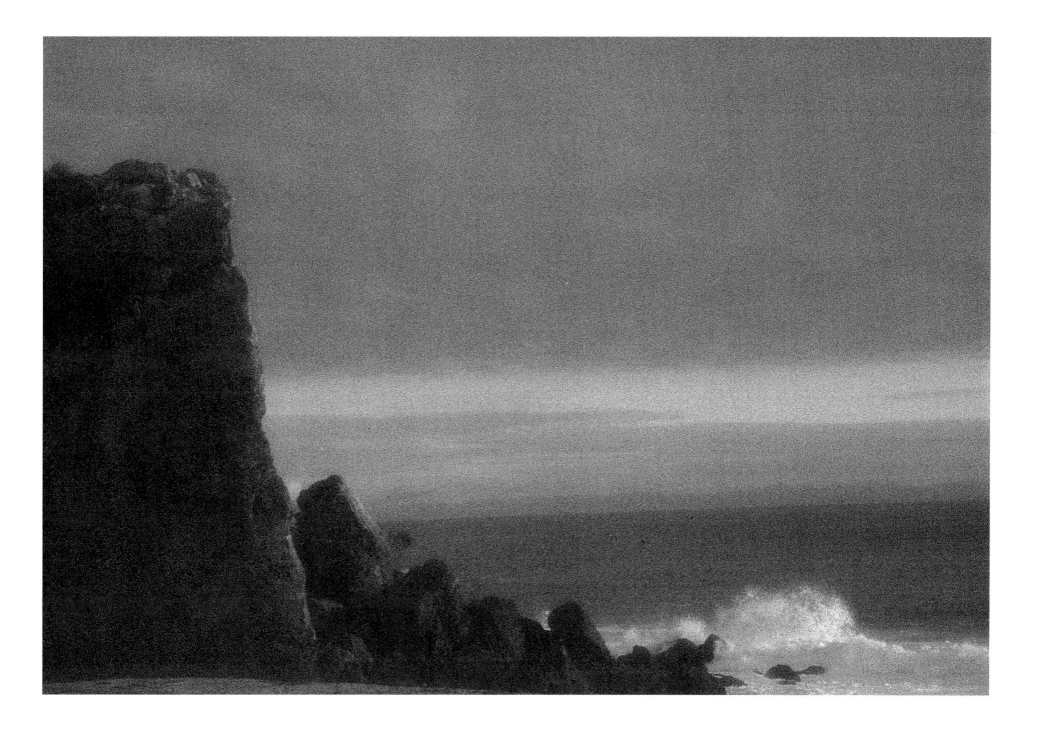

I love the sound of the sea, the look of the sea, the constant motion of the sea, the color of the sea, the many moods of the sea. I think I'm in love!

— Phyllis Diller

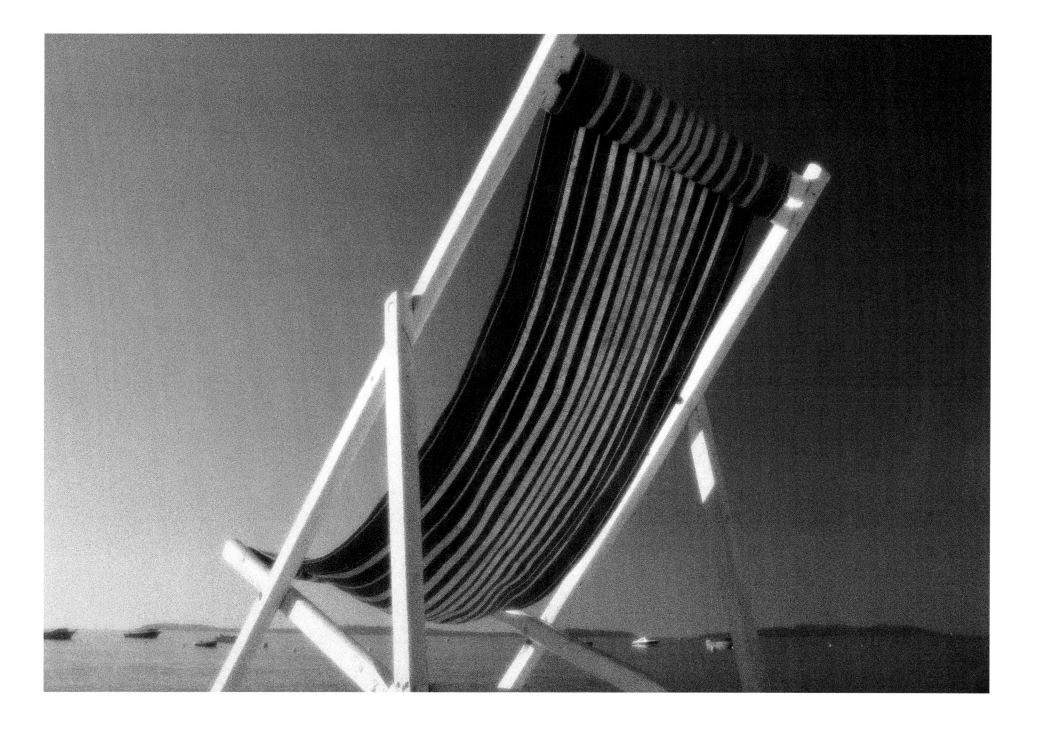

It puts me in my place
And makes me like it there!

Anne Bancroft

No. 39
ANNE BANCROFT, ACTRESS

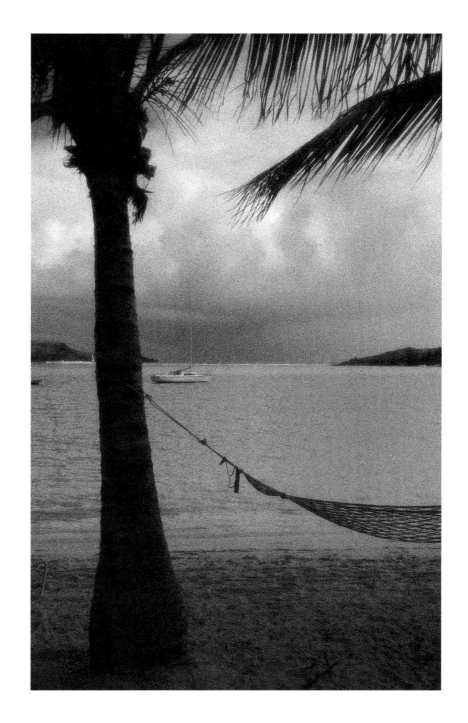

The Old Horst and The Sea —
As I grow older and reflect
on my wonderful life, I
realize with gratitude what an
inspiration The Sea has been To
me, as To So many other
artists.

Quite Simply, and with
respect, I acknowledge without
The Oceans This wonderful life
would cease To exist.

Horst

4/96

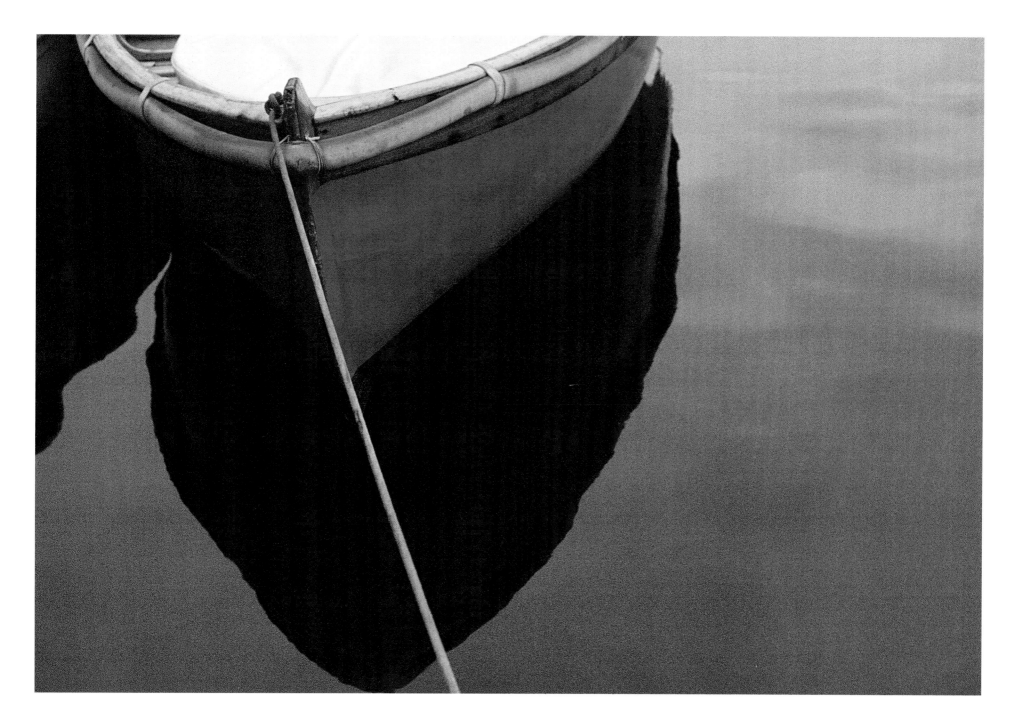

"Who can sail without wind
Who can row without oars
Who can part from their dearest
without shedding tears."

I remember the soft words mixing
with the flutter of small waves
against the hull. Peace and
tranquility — a lifetime ago.

No. 41
LARS FREDELL, BUSINESS EXECUTIVE, STOCKHOLM, SWEDEN

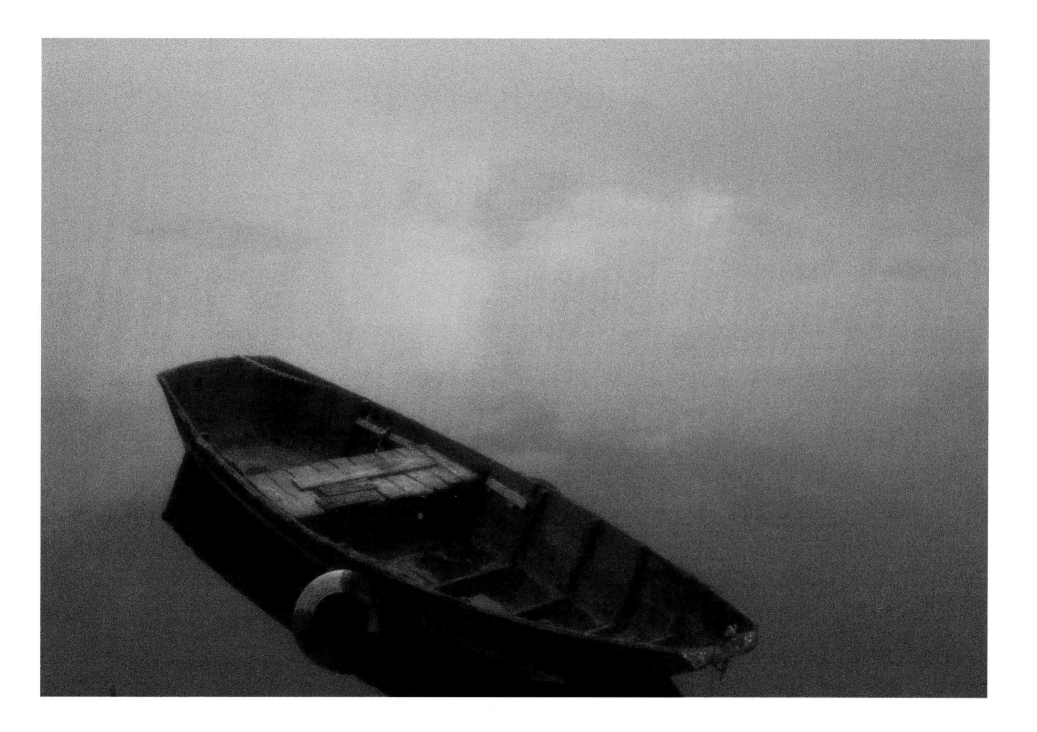

Hi! this is James Brown
When Im by the Sea, I get the
Feeling, I mean it has A Romantic
Feeling And also it makes one
Think Deep God Bless you James Brown

No. 42
JAMES BROWN, RECORDING ARTIST

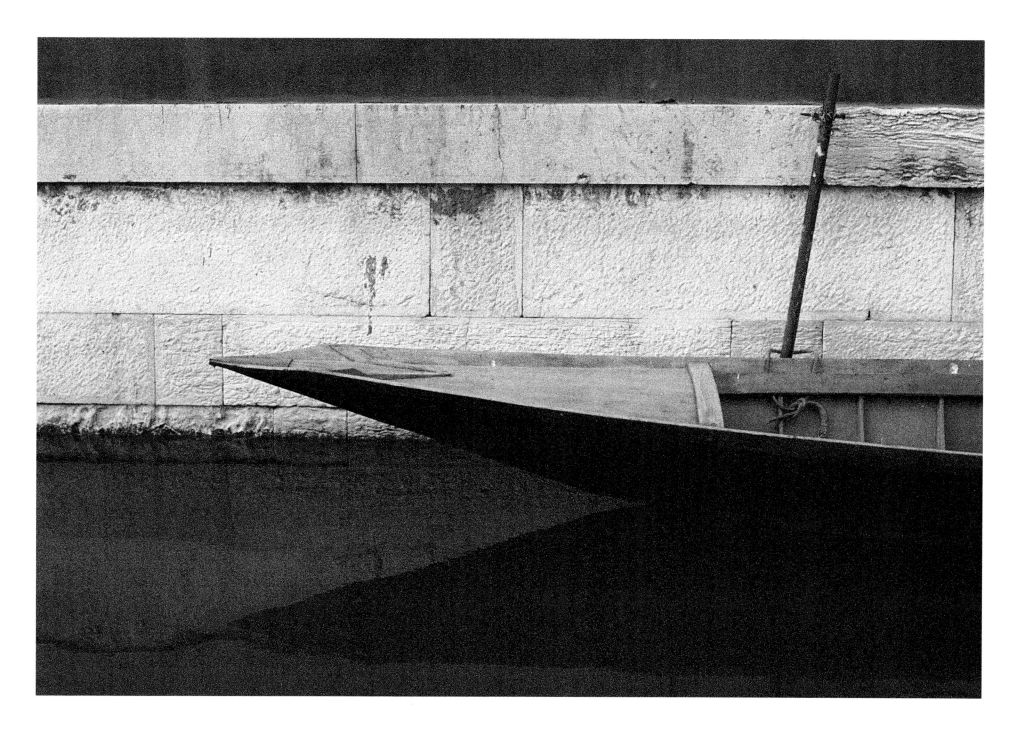

Being by the Sea
means work to me

C. G. Overton

C. G. OVERTON, COMMERCIAL CLAM DIGGER, HAMPTON BAYS, LONG ISLAND

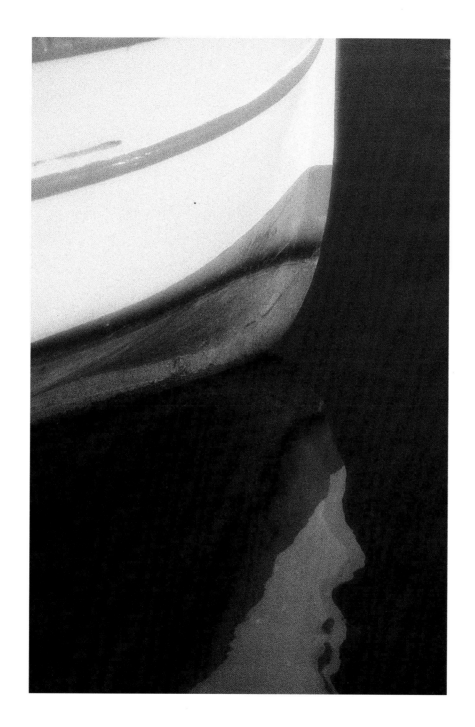

The sea continues to feed our spiritual need for adventure into the unknown,

Robert Ballard

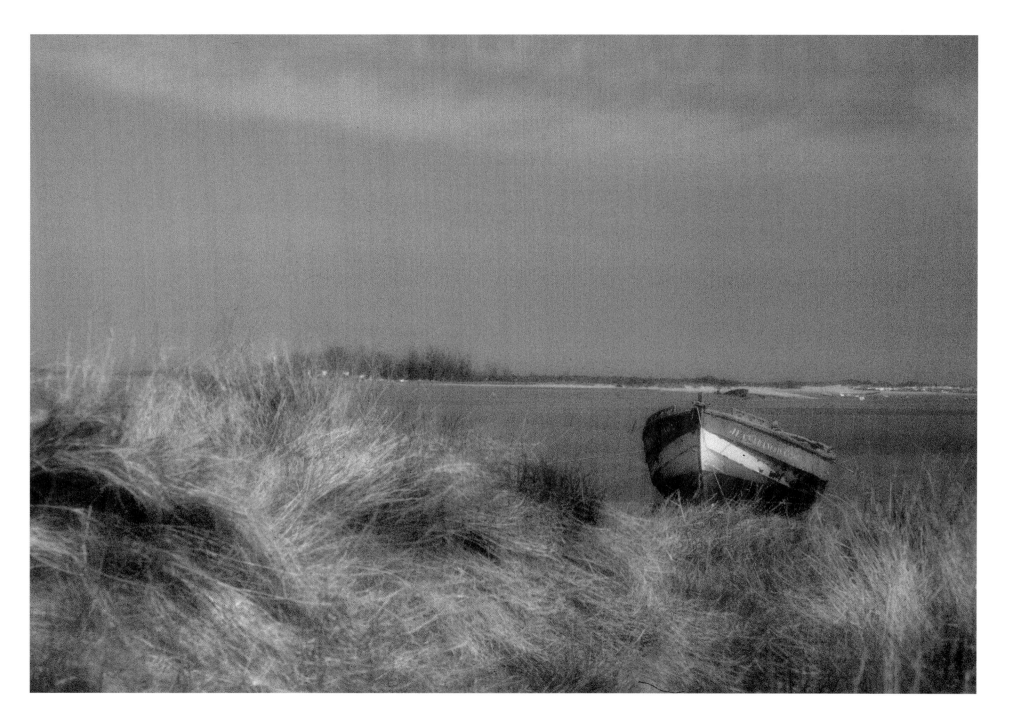

When I am in or near the ocean
I feel the ultimate release of tension.
Gene Rink

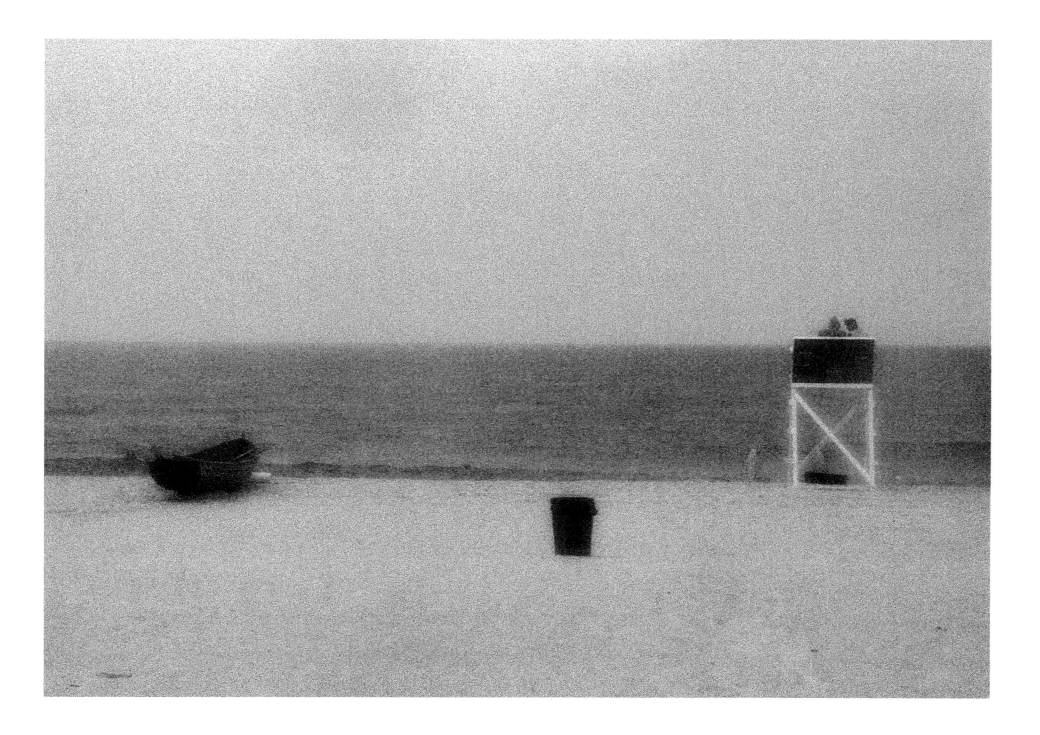

The sea reminds me of my childhood; running in and out of the
waves to get the sand out of an itching wool bathing suit.
It reminds me of teen picnics and body surfing and being
rolled by the waves. It reminds me of sailing vacations with
our children. The sea is for me many happy memories.

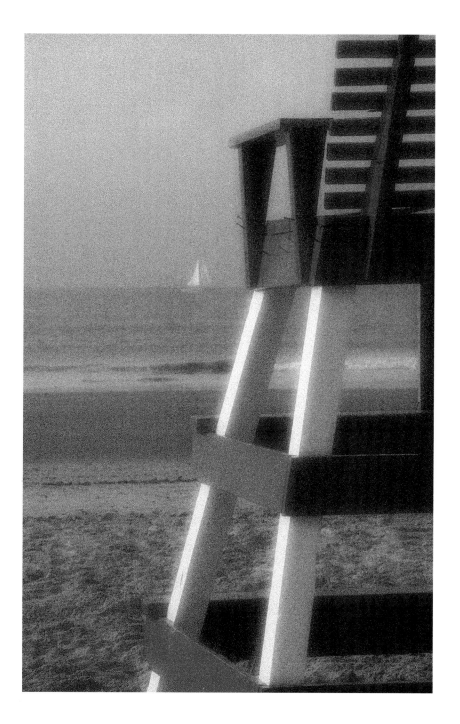

Being deaf, the sea is a visual experience
I imagine the thrill of being face to face, unharmed,
with a great white !! But who would want to
read his lips ??

Ken Levinson

No. 47
Ken Levinson, president, Alexander Graham Bell Association for the Deaf

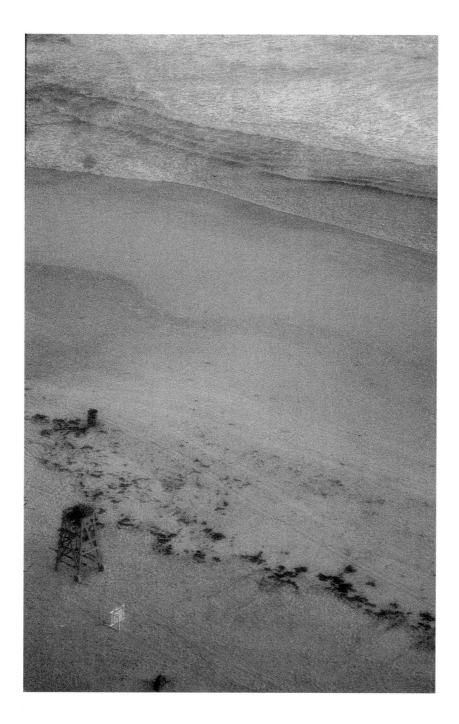

Just like a lover —
So familiar and comforting
... So wild and unpredictable —

Gerry & Jean Heron-Connick
Innkeepers, The Century House
Nantucket Island

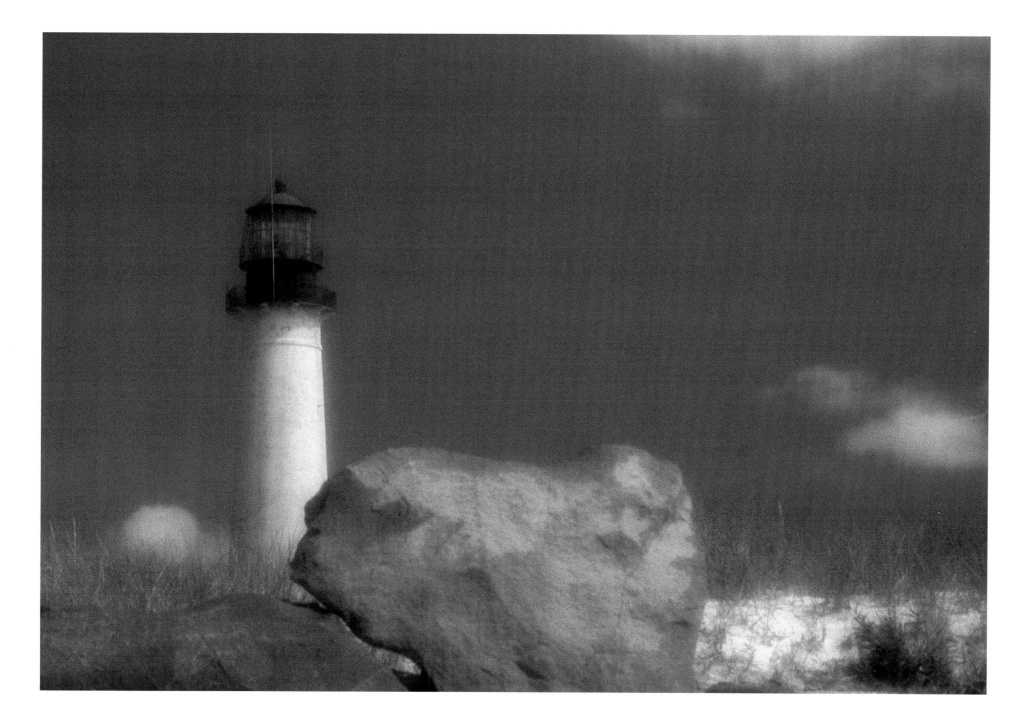

The sea makes me feel in touch
with the universe — a rather complete,
whole, sensuous person not the
nut-case workaholic I usually am!

Helen Gurley Brown

No. 49
HELEN GURLEY BROWN, FORMER EDITOR, COSMOPOLITAN

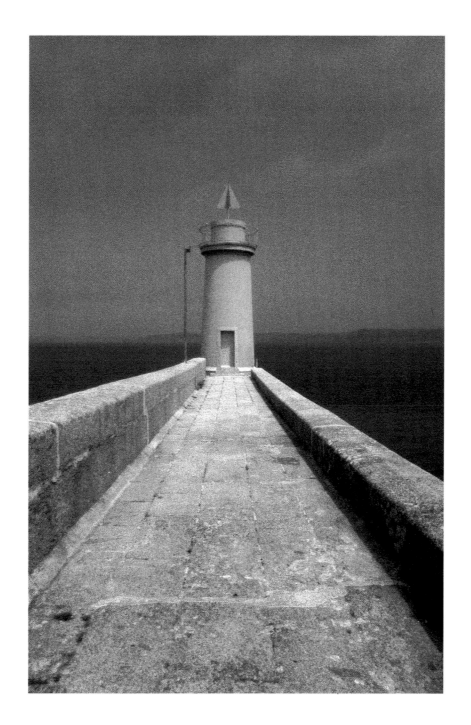

As you might imagine,the sea has always been a 'friend' to the
songwriters, (I speak as Pres. Of The Songwriters Hall of Fame and
one of the board of ASCAP) Writing a song for Frank Sinatra to sing
in the film ANCHORS AWEIGH Iwrote the following words for Jule Styne's
beautiful melody,---

 WHAT MAKES THE SUNSET, WHAT MAKES THE MOON RISE
 WHAT MAKES THE TIDE,REMEMBER TO HIDE,AND WHY DOES IT SOON RISE?

And for the show HIGH BUTTON SHOES,again to Jule Styne's music,

 ON A SUNDAY, BY THE SEA
 OH YOU OUGHT TO SEE MY SWEETIE AND ME,---

I am most appreciative of the sea for more reasons than the obvious
 ones,---

 Sammy Cahn.

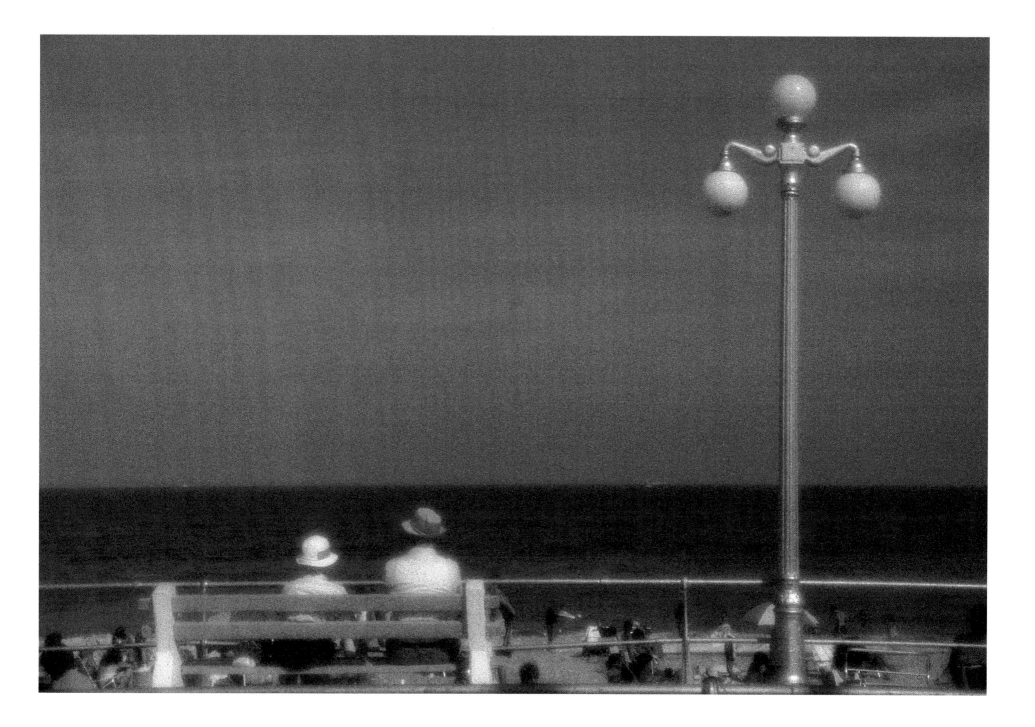

When I forget how talented
God is —
I look to the Sea.

Whoopi Goldberg

No. 51
WHOOPI GOLDBERG, ACTRESS/COMEDIENNE

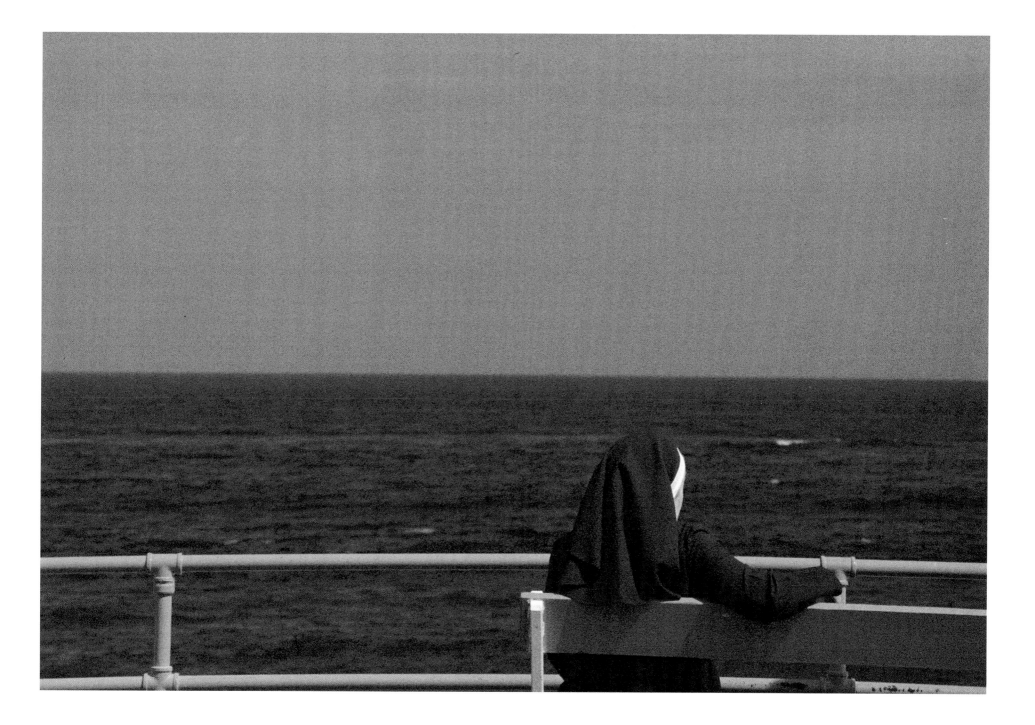

When we can walk on air
Then we will dream in the water
and the waves
wash upon the shore
searching for the lost bikini ...
for without the sea
in all it's splendor,
there would be not a fish,
nor a sushi bar ...

Stephen Bishop

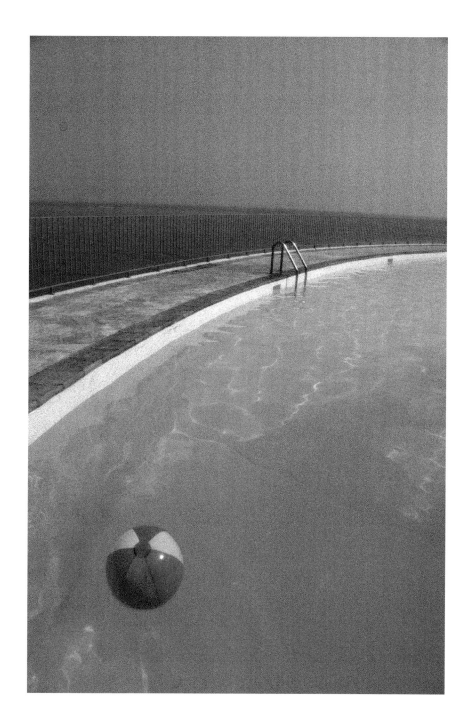

By the sea! — It washes me, and leaves the taste of salt. — Dumbfounded — look at my skin. — and count the waves.

Joe Baum

No. 53
JOE BAUM, RESTAURATEUR

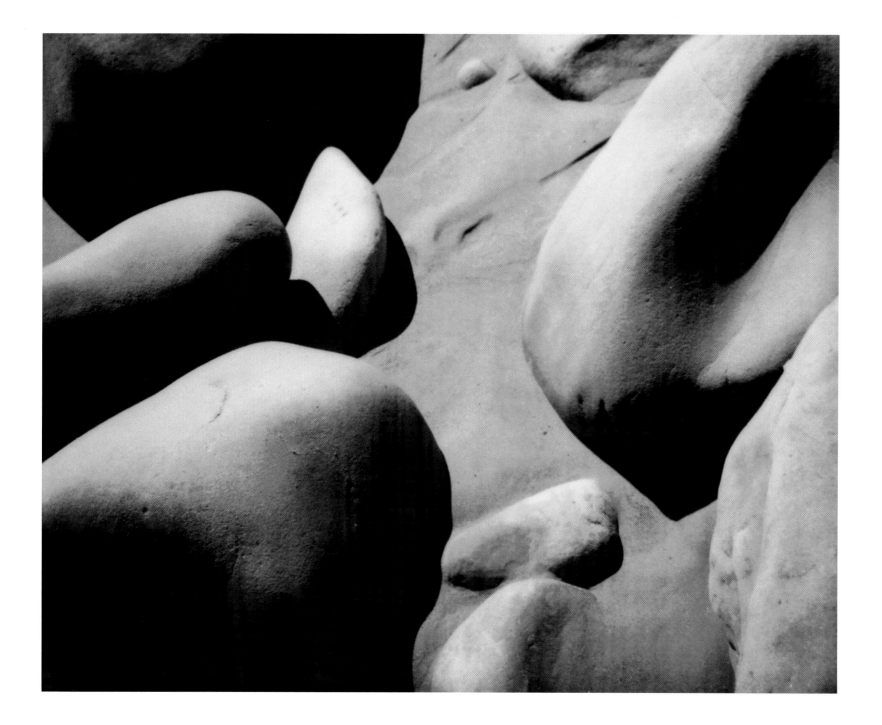

The Sea is constant change — and infinite unity.
Reminding me of our mortality — and that we are
all part of eternal life.
The streams and the rivers reaching the Sea
— ceases not to live — but continue as a
necessity of the whole.
For a while I am part of Her tides and Her
storms and Her stillness and Her mist and
Her rain.
In the Sea I realize the hidden purposes of
all things. Liv Ullmann

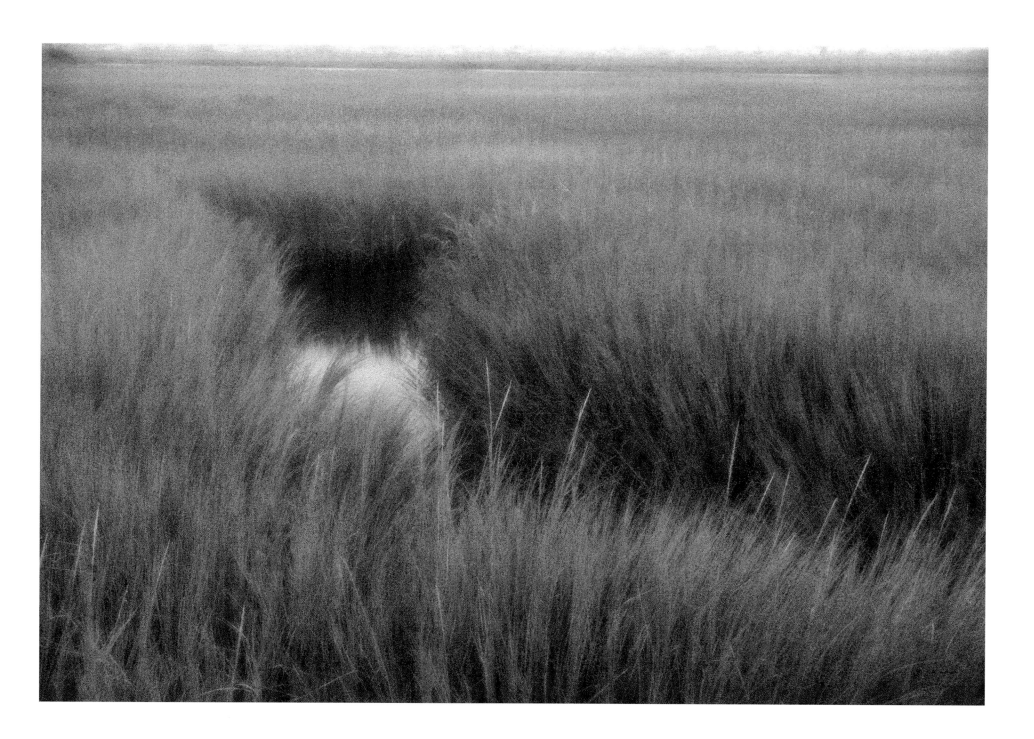

A man born of the sea,
by the sea,
for the sea —
I always knew what my life would be,
and this is the heritage I leave to thee

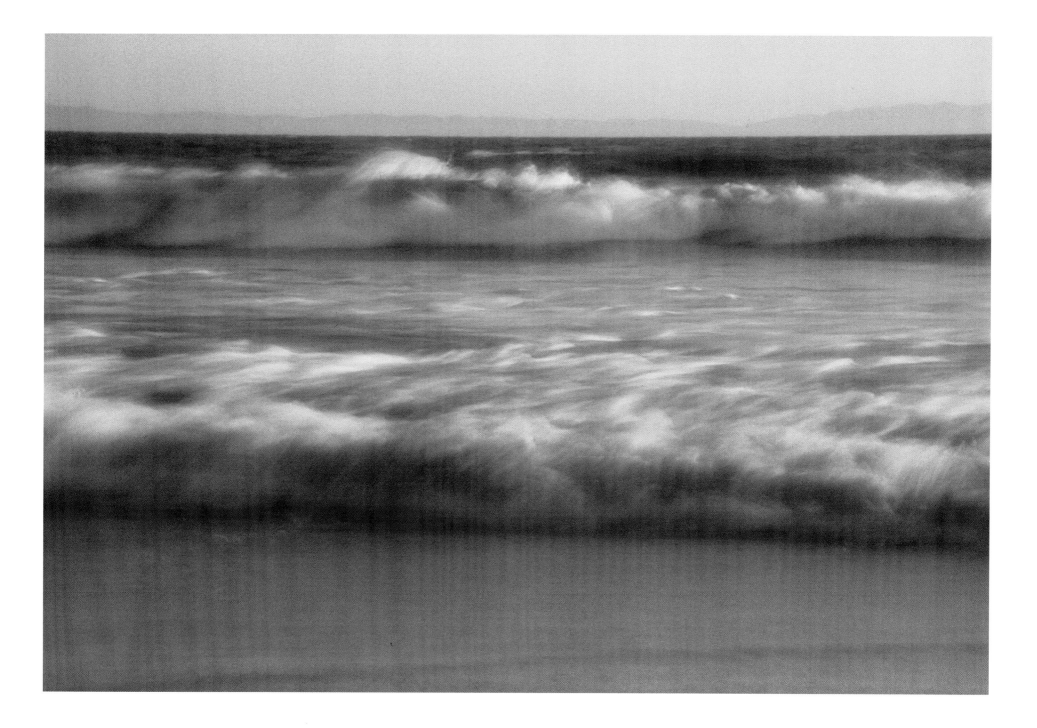

The Sea and I, live together with respect and awe.

Jemima York

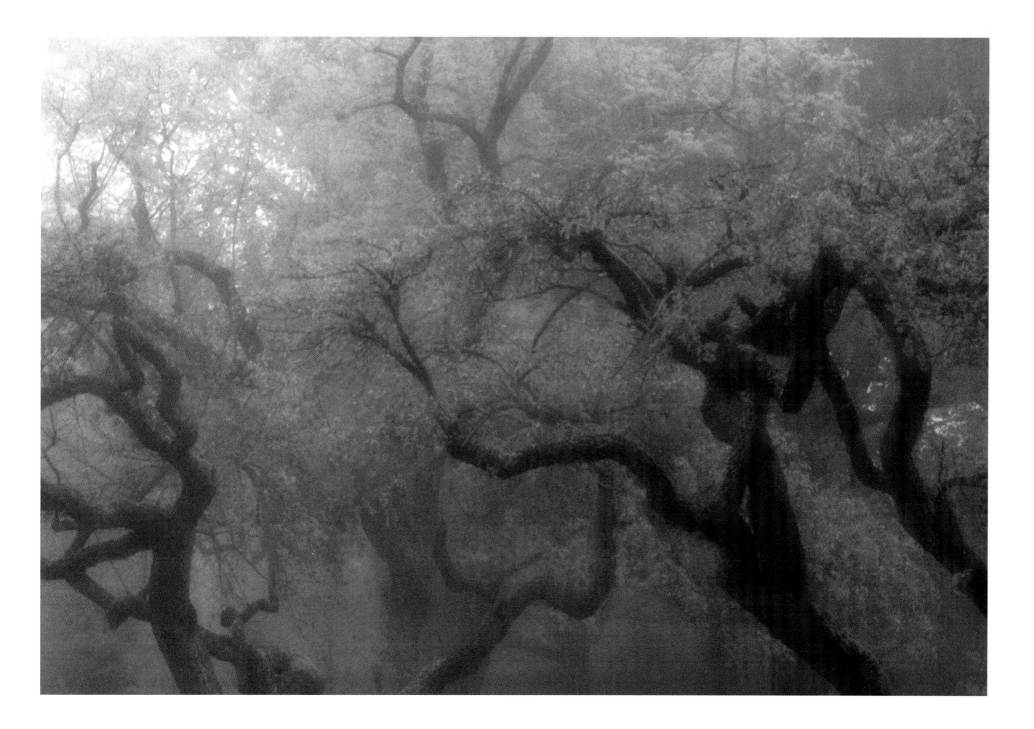

The Sea is within us.

Yoko - Ocean Child - Ono

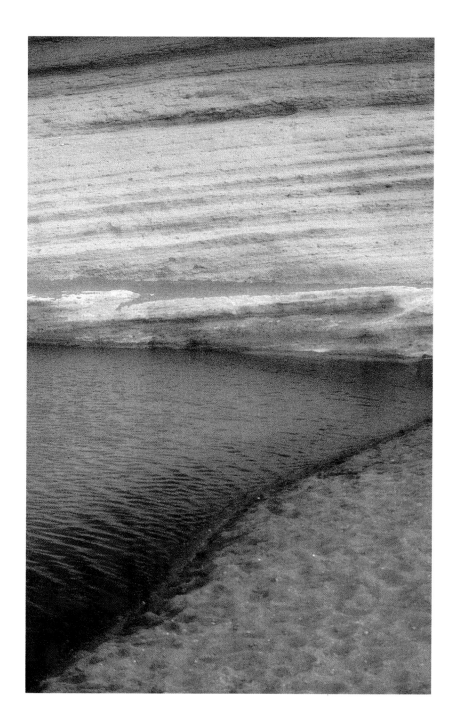

It is my solace and my salvation. When I despair I go to the sea and it reminds me that things go on.

Blake Edwards

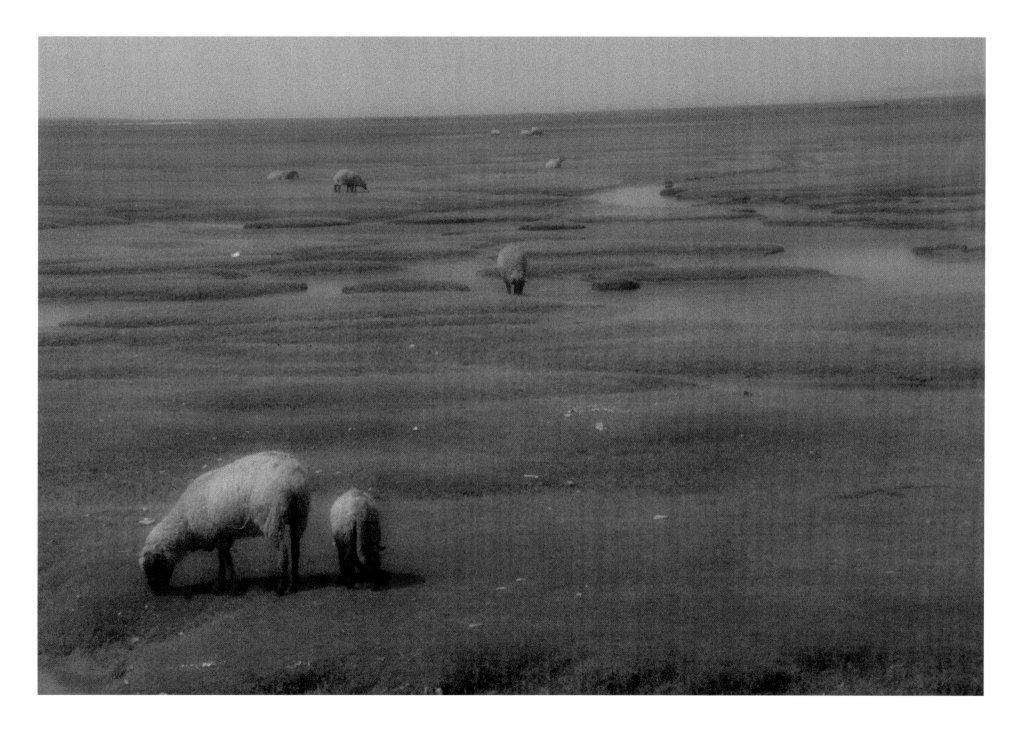

THE SEA SETS OFF MY
SENSES. THE SOUND OF
THE WAVES, THE SMELL OF
A TIDAL FLAT, THE TASTE
OF AN OYSTER, THE FEEL
OF THE SALT SPRAY IN A
SQUALL AND THE SIGHT OF
A MOONBEAM STRETCHED OUT
ACROSS THE GULF STREAM
REMINDS ME OF WHERE I
CAME FROM.

Jimmy Buffett
Key West

No. 59
JIMMY BUFFETT, RECORDING ARTIST

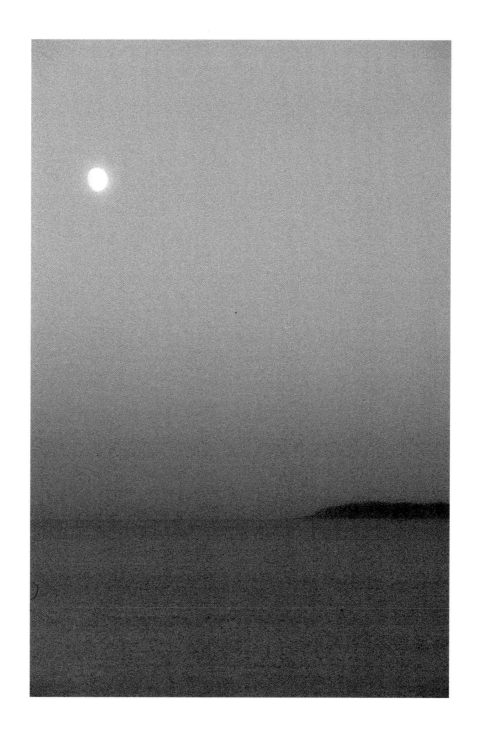

WHEN just a child I thought:
 "With each and every wave,
 Something new is brought ashore
 And more importantly - to me!"

AND Now, more wise with age & living,
 I'm touched that still it feels the same
 When e'er I watch this unchanged
 Yet ever changing sea.

Judd Hirsch

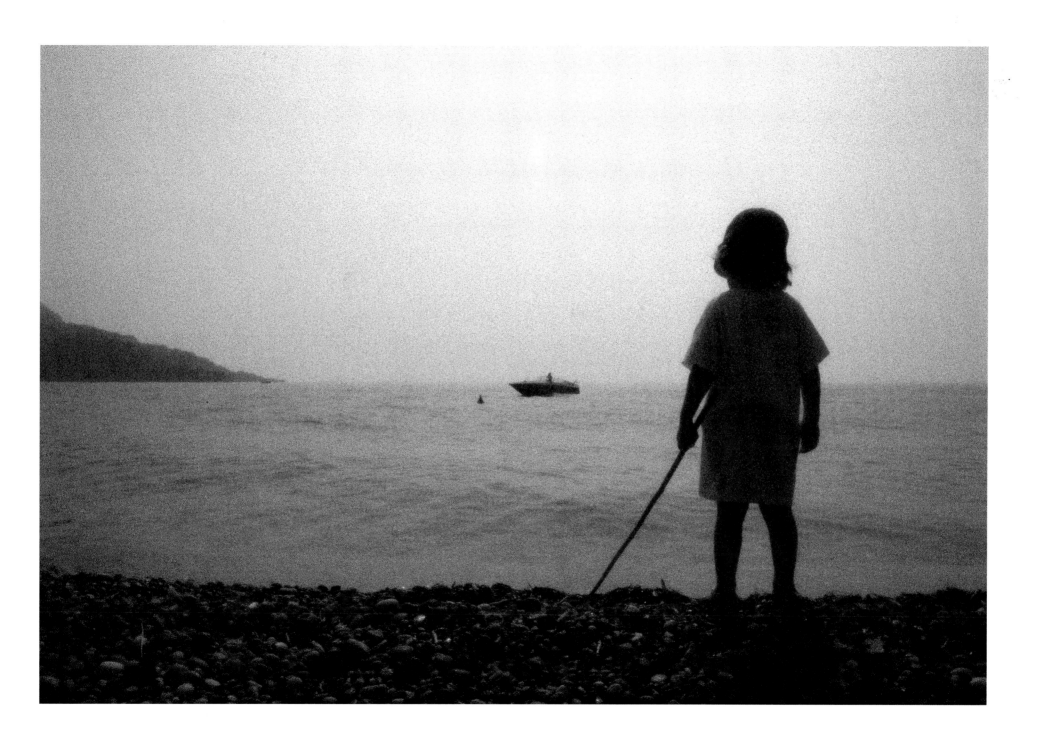

PERSONAL THOUGHTS AND TECHNICAL NOTES

All the images in this book were recorded on Agfa film. The film speeds used varied with the individual images and have been indicated in the following background Notes. In most cases Robert Farber used Agfachrome 200 or 1000; all images were shot on transparency film. Robert Farber shoots mainly in two formats, 35mm and $2^{1}/_{4}$, using two systems: the Canon EOS and the Hasselblad. The images in this book were taken with 35mm.

Robert Farber used three types of filtration, not necessarily all at once. These varied depending on the subject or the time of day. The filtration included an 81B filter to warm up the subject, a polarizing filter to saturate the colors and light, and a diffusion filter (generally hairspray on a UV filter) to reduce the contrast and enhance the mood of the image.

Tiffen, a major filter manufacturer, has been working along with Robert Farber to develop filters that combine variations of warm tones, diffusion, and polarizing effects, which will result in the look Farber has achieved in his style.

Visit Robert Farber's web site, http:/www.farber.com

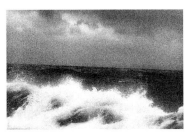

High Sea, Atlantic Ocean. I was on an assignment that took me out to sea on the *Queen Elizabeth II.* On a day with rough weather, against the better judgement of my stomach, I went below deck to the porthole closest to the waterline and shot this photograph.

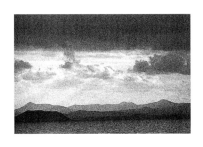

Canary Islands. This was photographed from the shore of Lanzarote, which is one of the Canary Islands off the coast of Spain. I was on one of the black-sanded volcanic beaches, looking toward a mountain range on one of the neighboring islands; above me was a stormy sky. Sometimes being by the sea can be an eerie experience. I used Agfachrome 100.

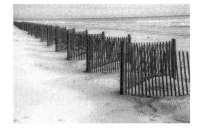

Zigzag, Long Island, New York. Most of Long Island's beaches are natural sand dunes, with sea grass growing on them— protective barriers that add to the beauty of the shoreline and are protected by law. In addition to the laws, however, the dunes are protected by dune fences, which often complement the area's natural beauty. This particular fence was in Southampton. I used Agfachrome 200 with an 81B and diffusion filters.

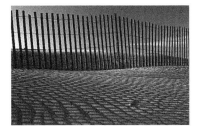

Dune Fence, Long Island, New York. It was summertime, when daylight saving time postpones sunset until 8:30. The warm early evening light was highlighting the structure of this fence and casting shadows on the beach at Montauk Point.

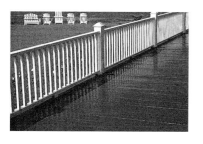 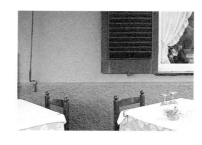

Sitting by the Sea, Block Island, Rhode Island. To me, this small, charming island typifies old New England by the sea. This photograph was taken from the porch of an old hotel whose ambience evokes in me the same euphoric feeling that I get from being by the sea. I will return here.

Yellow Boat, Yellow Wall, Italy. I found this boat drydocked at Portofino harbor and composed it into what I thought would be the most interesting image—more than merely a boat lying upside down against a wall.

Separate Tables, Italy. This photograph was taken at a seaside cafe on the dock in the Portofino harbor. I used Agfachrome 100.

Still Life in an American Snack Bar, Long Branch, New Jersey. I was only going there for a hotdog. This image was shot on Agfachrome 100.

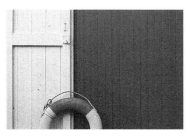

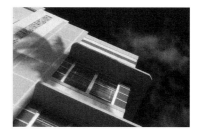

Red Lifesaver, Italy. After photographing Red Cabanas (see No. 15), I traveled across the small inlet to explore the cabanas further and saw this red and white lifesaver. Perfect.

Cabana Key, Italy. This was photographed at a cabana on the Italian coast— one of the same cabanas that appeared in Red Cabanas (see No. 15). This time, however, I got closer to the subject and was able to explore it in detail.

Miami Beach Hotel, Florida. The southern-most stretch of Miami Beach was built up in the 1920s and 1930s, then slowly deteriorated as the Northern part of Miami Beach, with its new luxury hotels, gained in popularity. In the 1980s, with the public's renewed appreciation for Art Deco design, the southern beach area underwent restoration. Even before the restoration, even before I began my career in photography, however, I found myself drawn to the area. Its appeal is utterly unique. I used Agfachrome 200 with an 81B filter to warm it.

Miami Beach Deco, Florida. The architecture of a building can determine the moods and memories of a seaside area as much as the natural forms and the water. This photograph was taken on Ocean Avenue and was composed to capture both the building and the street lamp. I used Agfachrome 200.

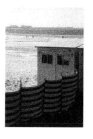

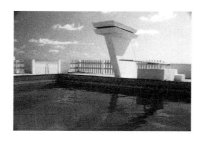

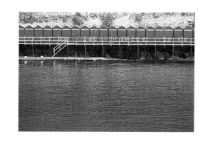

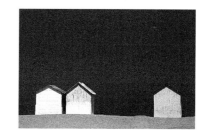

Belgian Beach Cabana, Belgian coast (near France). This was recorded on Agfachrome 200, with a diffusion filter.

Deco Diving, Florida. This photograph was shot at a Miami Beach hotel that was built in the 1930s. The architectural continuity extends out to the pool area, with its Art Deco-styled diving board. I used Agfachrome 200.

Red Cabanas, Italy. This was taken at the same time as both Red Lifesaver (see No. 9) and Cabana Key (see No. 10). I used Agfachrome 100.

Two Cabanas and One Alone, France. Cropped any other way, this image, shot on the coast of Normandy, would have to have been titled differently.

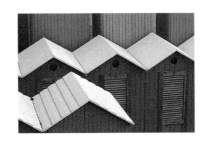

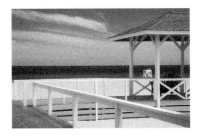

Cabanas of Normandy, France. On this part of the Northern coast of France, the beaches are filled with wooden cabanas, re-creating the ambience of a bygone era and offering numerous photographic possibilities.

Blue Cabanas, Italy. This image was recorded in Santa Margarita on the Italian coast, not far from Portofino. For me, this characterizes the feeling of the Italian beach, a quality that is altogether unique to that country.

End of the Road, France. Traveling along the coast of Normandy is a totally unique experience. Whereas other seaside areas seem to lift one's spirits or banish one's cares, the Normandy coast with its numerous World War II memorials, has such a pervasive sense of history that individual reasons for seeking out the seashore seem irrelevant. This car, sitting alone at the water's edge with the stormy sky above, characterized my feelings. The film was Agfachrome 1000.

Beach Club, Nantucket, Massachusetts. This was shot on Agfa RSX200 at the same beach club as *Umbrellas at Nantucket* (see No. 23). I returned several years after taking *Umbrellas* to take this image. I used four filters: 81C, polarizing, coral, diffusion.

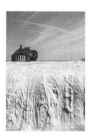

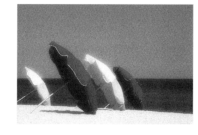

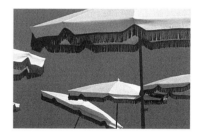

Sand Cliff, Fire Island, New York. Although it looks as if this house sits upon the cliff, the "cliff" was only two feet high and the house was actually quite far in the distance. Imagine the waves breaking on the shoreline. Picture how they sometimes erode away the sand, forming a "step" that invariably crumbles if you try to put your weight on it. By using a 24mm lens, I was able to distort the perspective and create the illusion of the house atop the cliff.

Beach Cabanas with One Orange Umbrella, Normandy, France. The monochromatic beach and the neutral tones of the cabanas help to set off any touch of color-like the orange umbrella. It is this single colorful element that makes the entire image work. I used Agfachrome 200 film.

Umbrellas at Nantucket, Massachusetts. I have frequently wandered among some of the small islands off the northeastern coast of the United States, often composing and capturing a still life or a landscape. Usually this means photographing something that would otherwise go unnoticed. When I walked onto this beach, which belongs to a hotel, the staff had set up the blue and yellow umbrellas as they do nearly every day, only this time, the graphic quality seemed more pronounced, and it was as if the image had been handed to me. I used Agfachrome 200.

Umbrellas, France. For many years I have returned to this beach at Cannes, on the French Riviera. Ten years earlier, in fact, I sat in almost the same spot and photographed one of my favorite images, "Death in Venice," which appeared in my book *Moods* (Amphoto, 1980). This image, however, was taken as I was leaning back in my beach chair. I was able to isolate these umbrellas to create a pleasingly graphic composition. I used Agfachrome 100 with a polarizing filter.

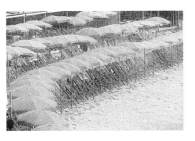

Green Umbrellas on the Italian Coast, Italy. In San Raphael on the Northern coast of Italy, these umbrellas are set up perfectly each morning in preparation for the crowds of people. The morning this was shot, I was the first to arrive.

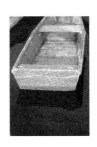

Water Highlights, Rockport, Maine. I photographed this boat in Rockport while teaching a nude workshop there.

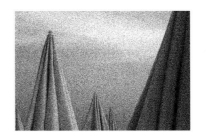

Umbrella Mountains, France. I often explore beaches in the early morning or late afternoon, when they are deserted and the light is at its most beautiful. On this particular afternoon the sky was overcast, but the effect was still interesting as I composed my picture to capture the umbrellas configured like a mountain range.

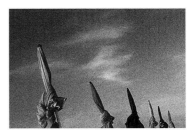

Umbrellas of Deauville, France. The seaside resort of Deauville sits on the northern coast of France. Its beaches, with their colorful umbrellas and chairs, were a popular subject for the Impressionists in the late nineteenth century. One of the reasons for Deauville's enduring popularity is its proximity to Paris; it is only about 100 miles away, as opposed to the Mediterranean coast, which is about four times farther. When they are being used, these umbrellas are almost like individual, tentlike cabanas. Here, they are tied closed with the fabric that spreads out to give them that quality.

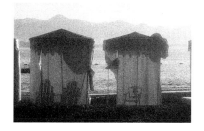

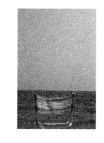

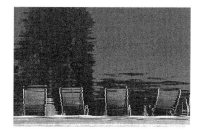

Beach Chair Resting on Umbrella, Deauville, France. This was photographed at the same time as Umbrellas of Deauville.

Canvas Beach Cabana and Morning Sunlight, Las Hadas, Mexico. I really enjoy waking early and walking along the beach. Not only is it the most peaceful time of day for me; the light does wonderful things.

The Horizon, Nice, France.

Reflections of Beach Chairs, France. I found these beach chairs lined up along the edge of the pool at a French resort hotel, reflecting into the water.

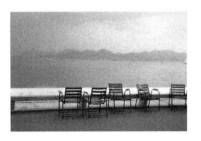

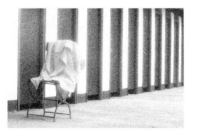

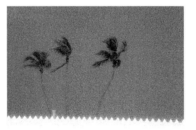

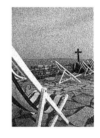

The Chairs on La Croisette, Cannes, France.
These chairs line the outer street along the
busy beach and walkway in Cannes, on the
French Riviera. My personal preference is
to spend time alone on a desolate beach.
There's something about La Croisette in
August, however, which is just the opposite-
exciting, energizing, crazy, and wonderful.

Chair and Towel at Cabanas, Northern Italy.
The weather was hazy.

Windy Palms, Ft. Lauderdale, Florida.
Photographed on a windy day.

Sun Worshipers,
France. Photograph-
ed in the south of
France, at an old
inn, this cross was
erected to protect
the sailors who went
out to sea. Now,
however, the sun
worshipers have
taken it over. I used
Agfachrome 1000.

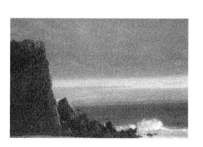

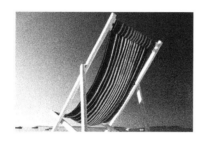

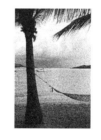

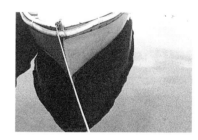

Malibu, California. I was shooting a commercial assignment in Malibu when I shot this scene.

Beach Chair, France. It was early in the morning when I walked along this beach in the south of France. The strong morning sun was filtering through the fabric of the chair. The wide angle, along with a polarizing filter and Agfachrome 1000, created the drama that I wanted to achieve in this image.

The Hammock, St. Bartholomew, French West Indies. How peaceful!

Red Boat, Italy. This photograph was taken in Portofino harbor on the Italian Riviera. By using a zoom lens. I was able to crop the boat from its surroundings, giving the image a strong, graphic quality. I used Agfachrome 100.

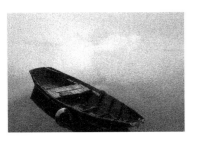

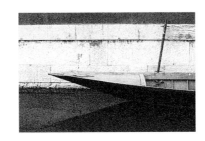

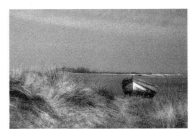

Evening Sunset Reflections and an Old Boat, France. Sometimes I find myself alone in a wonderfully romantic setting. With a camera, at least I can capture the moment and share it. I shot this on Agfachrome 1000.

Gondola, Venice, Italy. There was no need to show all of the boat. Sometimes, as here, a simple line says it all in a more interesting graphic statement.

Reflections of a Boat's Bow, Maine. A fishing boat moored in the harbor of Rockport, Maine; the early morning light is making its reflection an abstract form.

Beached in Sea Grass, France. The boat seems to be abandoned in an empty field. But I shot this image on the Northern coast of France, near Mont St-Michel, where the tide recedes three miles every day, leaving everything behind it beached. I shot this image on Agfachrome 1000, using 81B and diffussion filters.

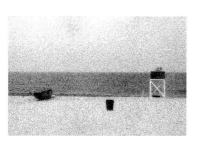

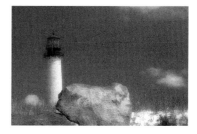

Dreary Day, New Jersey. It was drizzling and damp as I made my way south toward Cape May, New Jersey. I stopped to capture this image around Long Beach, New Jersey. I used Agfachrome 1000 with 81B and diffusion filters to enhance the mood.

Lifeguard Stand, New Jersey. Walking along the beach one early morning in Cape May, New Jersey, I saw this red and white structure highlighted in the morning light. Suddenly, in the sea beyond, a sailboat glided by. I quickly got into position and working with the zoom lens I was able to capture the position and size of both subjects. The film was Agfachrome 1000, augmented with a polarizing filter.

One Red Lifeguard Stand, Florida. I had just checked into my hotel room in Daytona Beach, Florida, where I had gone to speak to the Florida Professional Photographers Association convention. I stepped out onto my balcony, looked down, then walked over to my luggage, grabbed my camera and started shooting from about the twelfth floor. This image is dedicated to those who invited me to speak.

Cape May Lighthouse, New Jersey. I've known about this lighthouse for many years; I saw photographs of it when I was a child. Before I began working on *By the Sea,* however, I had never ventured to the southernmost point of the New Jersey shore to see it. The charming architecture of the town of Cape May was a wonderful surprise. The lighthouse was located quite a distance from the rocks in the foreground, but by using the 135mm lens, I was able to foreshorten the image to create this composition, juxtaposing the structure with the natural beauty of the coastline.

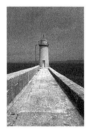

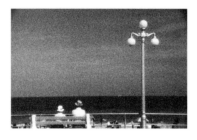

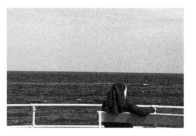

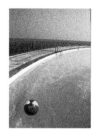

Green Lighthouse, France. It was a cloudy day. I was traveling along the north coast of France, when I stopped to take a closer look at an old lighthouse that was sitting at the end of a pier in the harbor. As I approached it, the sun began to break through the clouds, turning the dull green color of the structure into a beautiful pastel. I composed the image around the lines of the pier, using a polarizing filter to enhance the colors against the background. Agfachrome 1000, with its inherent graininess, added to the feeling I was after.

Boardwalk Beach, Bradley Beach, New Jersey. When I first started working on *By the Sea,* one of the first trips I made was to the section of the New Jersey shore where I had spent my summers as a child. Sadly, I found that the wonderful old Victorian board-walk pavilion, with its many coats of white paint, had been replaced by a McDonald's. The only things I recognized from the past were the street lamps, unchanged except for their new silver paint jobs.

Blue Nun, Asbury Park, New Jersey. The sea is probably the only place where one could do nothing and at the same time do so much for oneself. I photographed this nun doing just that.

Beach Ball at Cap Estel, France. This was photographed at one of my favorite oceanfront hotels, Cap Estel in Eze-sur-Mer, which is a small seaside town right near the Monacan border.

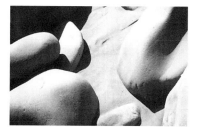

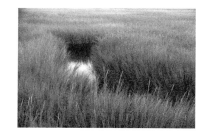

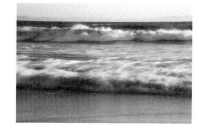

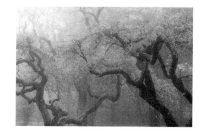

Rocks, Santa Barbara, California. I have been living between New York City, and Santa Barbara. When I am in Santa Barbara I often find myself visiting the same particular area of a beach where I found these beautiful rounded rock formations. I have been photographing them in every format with different kinds of film, as if they were parts of someone's body. This time I used a Spector Polaroid camera with three filters held in front of the lens: 81C, Coral, and diffusion

New England Marsh, Maine. On the northeastern coast of the United States, swamplike areas filled with sea grass are common. These marshes which seem to flow softly with the blowing winds, lend themselves beautifully to photography and painting.

Waves, Santa Barbara, California. This was shot on Agfa RSX 200 using a combination of three Tiffen filters: half coral, 812 and diffusion filters and shot at 1/15 of a second. This is a beach where I often go and spend time.

Blossoms, Southport, Connecticut. While exploring the Connecticut coast, on Long Island Sound, not far from the water's edge, I found these trees. Although this image's connection to the ocean isn't immediately clear to the casual observer, someone who spent time on this beach as a child would probably always associate such trees with being by the sea. This photograph was shot using Agfachrome 200.

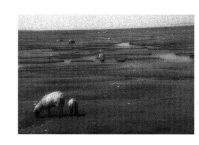

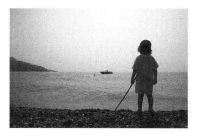

Water, Sand, Rock, Canary Islands. Quite some time before I began working on *By the Sea,* I was on the island of Lanzarote, in the Canary Islands, on a fashion shoot for Saks Fifth Avenue. Needless to say, I seized every opportunity I could find to photograph just the images I wanted. The island, which is an extraordinary mass of volcanic rock, looks the way the surface of the moon must. Photographing landscapes there brought out the abstract qualities in this image. I used Agfachrome 64 and pushed it one and a half stops.

Sheep at Mont St-Michel, France. I know that grazing sheep seem like an odd subject to include in a book about the seaside. If these sheep were to remain where they are when the tide changed however, they would be under water. In Mont St-Michel the tide ebbs about three miles every day, affecting both the geography and the way people live. I came across this scene by accidentally driving down a dirt road that was supposed to dead end at the water. Instead I encountered this beautiful, yet eerie sight. I used Agfachrome 1000 with an 81B filter.

Sunset at Le Lavandou, France. I'd been traveling along the Mediterranean from Marseilles, making my way toward Monaco, when I decided to stop for the evening at Les Roches Fleurs, a wonderful little hotel in Le Lavandou. My room was right at the sea, and adjoining the room was a small terrace with a ladder that led directly down into the Mediterranean. At check-in time, however, I was more taken with the beautiful sunset.

Devon, France. As I sat on a gravelly beach in Eze-sur-Mer, my two-year-old son, Devon, stick in hand, walked to the water's edge. The magic of the seaside is accessible at any age.